And

EVERY DAY

WAS

OVERCAST

Published by Black Balloon Publishing
www.blackballoonpublishing.com

Copyright © 2013 by Paul Kwiatkowski
ISBN-13: 978-936787-07-4

Black Balloon Publishing titles are distributed to the trade by:
Consortium Book Sales and Distribution
Phone: 800-283-3572 / SAN 631-760X

Library of Congress Control Number: 2013934168

Designed and composed by Christopher D Salyers • christopherdsalyers.com

Printed in Hong Kong

9 8 7 6 5 4 3 2 1

And **EVERY DAY** WAS **OVERCAST**

by Paul Kwiatkowski

BLACK BALLOON PUBLISHING

NEW YORK

For Allison Woodruff and my parents

Don't cry. If you have become human enough to cry,
then all the magic in the world cannot change you back.

—The Last Unicorn

Don't let the sadness of the swamps get to you.

—The NeverEnding Story

TABLE OF CONTENTS

ACID
DANCER

p135

ATTEMPT
FAILED

p173

RODE HARD
AND PUT
AWAY WET

p207

KID TESTED,
MOTHER
APPROVED
PART II

p241

4/20/99
SQUELCH
CAPTURE

p273

1996

1997

1998

1999

p153

FACE
BREAKER

p189

PIRANHAS

p229

FINAL
TRANSMISSION

p257

COMMUNITY
SERVICE

9-26-99

PAUL,

HEY BABY. I CAN'T HELP THINKIN BOUT YOU AND WHAT HAPPENED AT YOUR HOUSE. IT WAS GOOD THOUGH, I'M GLAD IT HAPPENED AND I'M KINDA LOOKIN FORWARD TO IT AGAIN, BUT I STILL WANNA BE CAREFUL AND I DON'T WANT IT TO BE ALL THAT WE DO OR ANYTHING IF YOU KNOW WHAT I MEAN. I'D LIKE TO KNOW MORE HOW YOU FELT ABOUT IT CUZ I KNOW YOU ALWAYS SAY IT'S UP TO ME & EVERYTHING, BUT I WOULDN'T MIND IF YOU TOLD ME WHAT YOU THOUGHT OR WANTED. IN FACT, I'D REALLY LIKE TO KNOW. I LIKED TALKIN TO YA ON THE PHONE TODAY. WE TALKED FOR A WHILE WHICH IS ALWAYS GOOD, IT MAKES ME HAPPY THAT I'LL SEE YA TOMORROW EVEN IF IT'S AT SCHOOL BUT THAT'S BESIDES THE POINT.... I CAN'T STAY AWAKE NE MORE BUT I'LL DREAM ABOUT YOU. I LOVE YOU.

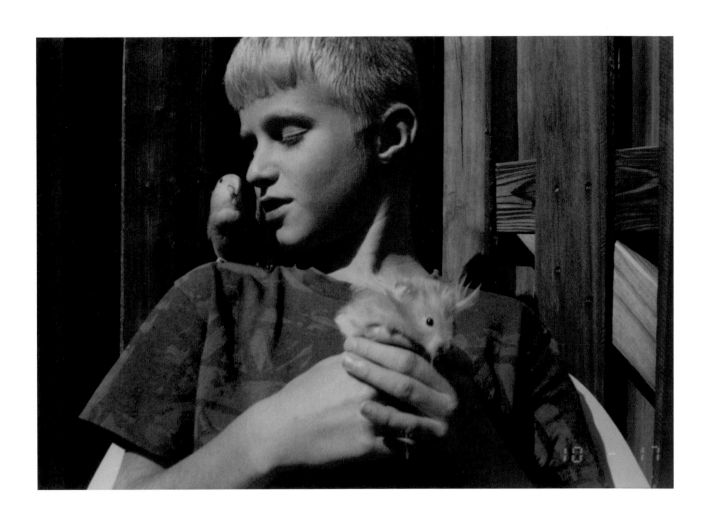

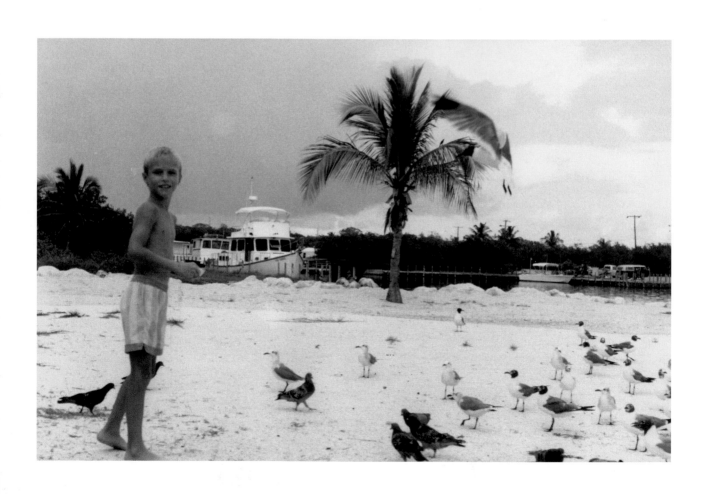

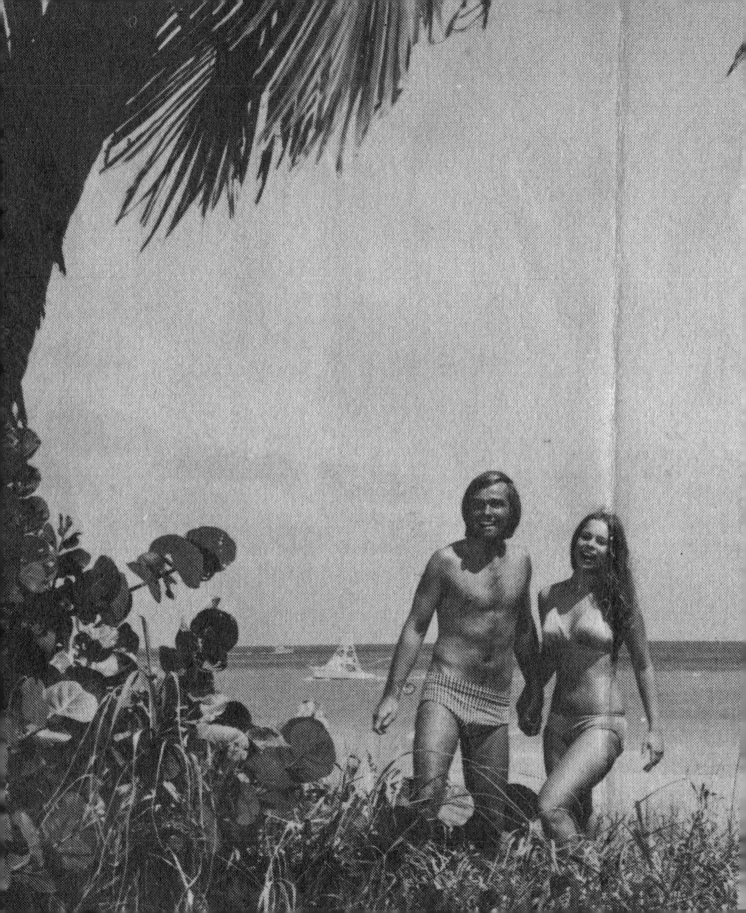

1991
MUSCLE MEMORY
SOUTH FLORIDA

✕

Memories of childhood humanize us as adults. With age, our version of that time is deformed then reassembled. What fragments bleed through are tailored to a narrative designed to hide vulnerability.

I remember watching *Wayne's World* at the theater with my aunt. During the car scene when Wayne and his friends sang along to Queen's "Bohemian Rhapsody," she went from hysterical laughter to tears.

After the movie, I learned that a close family member who I thought had died of cancer had in fact died of complications from HIV. Something shapeless sloughed off my shoulders, fluttered then stiffened inside my chest. That would be the first time in my life I understood the term "dying inside."

My hometown, Loxahatchee, was built over Seminole Indian burial grounds. In exchange for land we inherited bad conscience. It was in my blood. I grew up in a paradise of strip malls, prefab housing, amusement parks, and other areas of diversion. My roots were steeped in shallow earth, easily extracted from amorphous terrain—swamps and beaches, neither land nor water.

At a friend's house, I made one of the most critical discoveries of my adolescence: the movie *Porky's*. During the glory hole/shower scene, I shot Polaroids of the screen. For years I carried around the photos in my back pocket and kept them under my pillow.

In elementary school I lived near the Kennedy Space Center. On launch days my school gathered in the parking lot to watch space shuttles take off. Even though I was young, I'll never forget watching the *Challenger* explode in mid-air. At the time I wasn't sure what happened. All I remember was a careening noncolor shape, followed by a thick spiraling trail of smoke. There were no screams. No loud explosion. No falling bodies. Just a twisted molten cloud. I wondered what it would feel like to know you were en route to space then abruptly reduced to shards and embers, falling over the ocean as the world watched.

The space center's proximity to my backyard came to signify an intersection between heaven and hell. Florida was somewhere between the two; it was America's phantom limb, a place where spaceships were catapulted out into the cosmos. Alligators emerged from brackish water. Vultures and hawks circled above. Mosquitoes patrolled the atmosphere at eye level. We shared an ocean with sharks and dolphins. There were no seasons, only variations of humidity. Time slithered, festering in a damp wake of recollections.

I believed in the Bermuda Triangle. I thought it would move in over Florida one night. By dusk an unknown force would vaporize us through a tear in the atmosphere. We'd be stuck, wandering in a parallel version of the same place, unaware that we were dead but dreaming.

People came here to vanish.

During moments of distress, I often thought about Mallory from *Family Ties*. In the show she wasn't depicted as especially nurturing. I guess I wasn't looking for stability. Maybe I just wanted a pretty girl in my life? Maybe it was because I was an only child who fantasized about having an older sister? I always preferred the company of women. Even my male friends were feminine. For the longest time, I figured I was a huge fag. *Family Ties* was canceled in '89. It took me a long time to comprehend that *Family Ties* was just a sitcom and that Mallory was just a character. Still I couldn't shake the betrayal.

I watched countless hours of television. I fantasized over female cartoon characters, even Muppets and Fraggles. My desires oscillated between the sexy cat from *Heathcliff* to Smurfette, Cheetara, Jem, and She-Ra. I experienced actual anger for Kermit the Frog not wanting to fuck Miss Piggy. I incessantly thought of these characters and they made my heart beat double. Even Betty Rubble and Daphne from *Scooby-Doo* gave me a hard-on before I knew what to do with it.

Supplemental to cartoons my favorite shows were *Unsolved Mysteries* and *America's Most Wanted*. I didn't start jacking off until seventh grade because I figured aliens were watching me from inside the closet. Every night I lay awake, terrified that I'd see part of a white, teardrop-shaped face with big black eyes slowly peek out from behind the closet door. The image came from a terrifying film with Christopher Walken called *Communion*.

Because of *Unsolved Mysteries*, I saw South Florida as a playpen for rapists, child molesters, and killers. I lived in constant fear of being kidnapped, dismembered, and thrown into garbage bags that would be disposed around the state.

My mother once made a half-assed attempt to wean me off *Unsolved Mysteries* and cartoons by encouraging me to watch a made-for-television miniseries based on the beloved childhood book *Anne of Green Gables*, a Victorian tale about a perky, chatty orphan with red braids. Unfortunately this only further perverted me. There was one scene in particular that always stood out in my mind. In it, Anne's best friend Diana gets hammered on raspberry cordials, then pukes in the bushes. As she politely coughed up more barf, something stagnated in my brain: She was my type. I wanted more of this in my life.

My favorite movie was *Predator*. It's about a hunter alien stranded in a make-believe jungle called Val Verde. The alien's point of view is shown as infrared, as seen when he is methodically hunting down a group of mercenaries led by Arnold Schwarzenegger. At the end of the movie, the alien commits suicide after he gets outsmarted by Arnold.

As a kid I watched *Predator* several times a week. I watched it so often that fragments of my dreams were infrared. When it happened, it was always the same scenario: I'm walking down an empty hallway that, in parts, reminds me of several schools I attended. I can even smell crayons and Elmer's glue. The negative spaces are black, outlined in neon blue. Since there are no other colors, I must be alone.

After wandering aimlessly, I lay atop a small patch of swamp hibiscus growing in the blackened hallway. The petals are tiny circular swirls of neon green, red, and violet. I can make out that inside the flower's base are tiny, crude human faces—two small black eyes, a perfectly circular mouth, and a little bulge nose. One of them nuzzles my ear and whispers, "Keep moving. Get to Val Verde." Then all at once they turn faint purple before slipping away into pixelated darkness.

I didn't overcome my fear of alien encounters until I was fourteen. I embraced the transition of replacing cartoon women with "real television girls" like Punky Brewster, the tall girl with fucked-up teeth from *Degrassi Junior High*, and Kelly from *Saved by the Bell*. I lusted after the inscrutable beauty of Winnie from *The Wonder Years*. I wanted to face-fuck the middle sister from *Full House*. I neurotically thought about what Blossom's aggro friend Six looked like naked. Hardly a day went by that I didn't think about Suzanne Somers' mouth wrapped around my cock and, despite Fran Drescher's grating voice, I wanted her giant WOP ass so badly that I'd lose my breath thinking about it. I wanted to fuck all the girls from *90210*, even the horse-faced one. I once jacked off to Angela, the old lady from *Murder, She Wrote*,

deep-throating me, eyes bugged out and blurry from behind thick bifocals. I didn't need porn—basic cable was sensory overload. I was defenseless against myself.

Of all the shows, *Married... with Children* stands out the most because of Peg Bundy. I know I'm supposed to want to fuck her daughter, Kelly, but I'm infatuated with her mother.

More problematic than my undying lust for the women of television was channel 22, the Squiggle Channel. Late at night, channel 22 would go from a void blue to hours of static.

The magic was that if I dedicated enough time to watching, shards of flesh would peek out from the jumbled signal. And if I got really lucky, I'd get a few seconds of flickering penetration.

During sleepless nights, I'd patiently watch the Squiggle Channel on mute until dawn. I once caught myself sitting right in front of the television for so long that the hairs on my arm were erect from the screen's static electricity. Most nights I saw nothing more than a few grainy minutes of distorted, gyrating flesh forming into the shape of a woman sucking a dick. That was all I needed.

On weekends my parents and I picnicked at a park near a landing site for skydivers. From beyond the tall silvery fence, I'd scrutinize the skyline for moments of free fall. No matter how bad the sun hurt my eyes, I wouldn't look away.

18

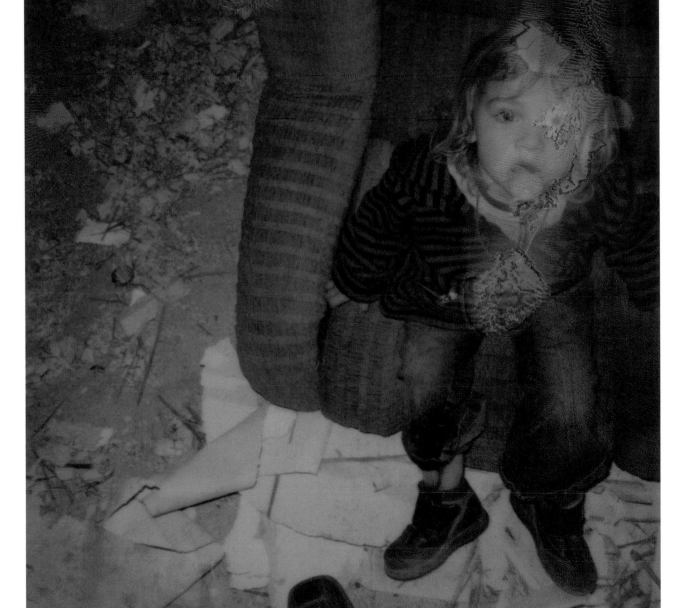

1991: MUSCLE MEMORY, SOUTH FLORIDA AND EVERY DAY WAS OVERCAST PAUL KWIATKOWSKI

TRANSMISSION

My mother was a private investigator for abused children. She rarely let me stay home from school. Even when I was legitimately ill, she'd make me go to work with her. She'd take me to migrant trailer parks rooted deep in the orange groves, secluded ghettos, and typical "perfect family" style development housing communities. I saw piss-soaked babies left alone on coffee tables, middle schoolers with black eyes, and kids cooped up in filthy homes crammed full of caged rabbits and animal shit.

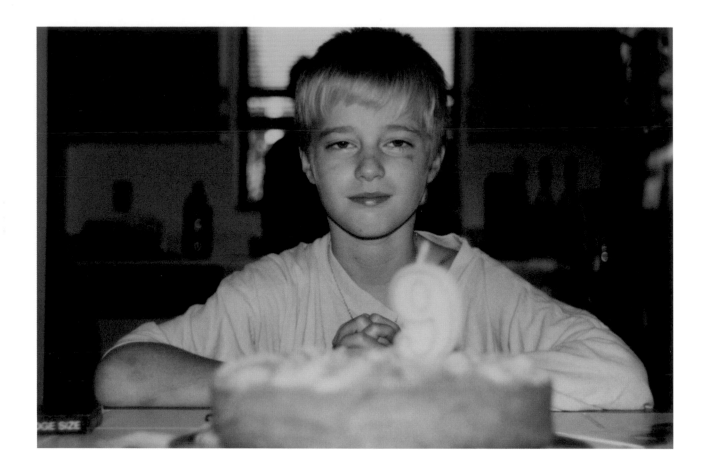

1991: MUSCLE MEMORY, SOUTH FLORIDA AND EVERY DAY WAS OVERCAST PAUL KWIATKOWSKI

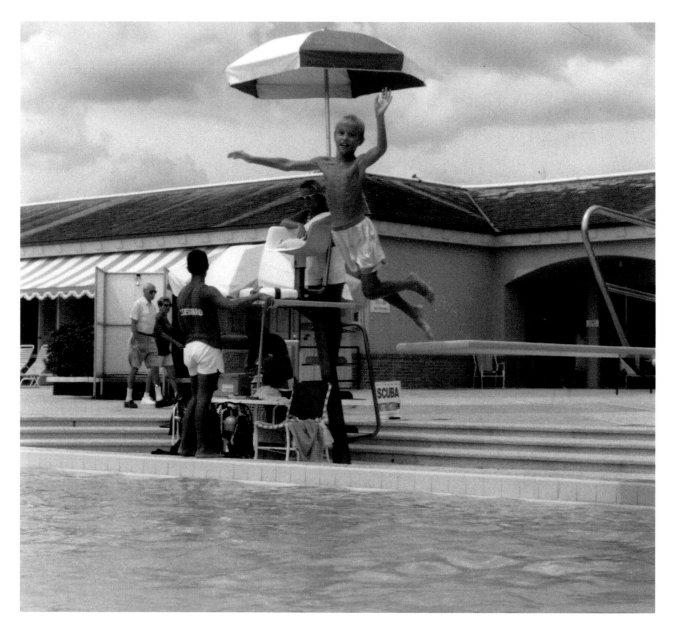

1991: MUSCLE MEMORY, SOUTH FLORIDA AND EVERY DAY WAS OVERCAST PAUL KWIATKOWSKI

PAUL KWIATKOWSKI AND EVERY DAY WAS OVERCAST **1991: MUSCLE MEMORY, SOUTH FLORIDA**

1991: MUSCLE MEMORY, SOUTH FLORIDA AND EVERY DAY WAS OVERCAST PAUL KWIATKOWSKI

1991: MUSCLE MEMORY, SOUTH FLORIDA AND EVERY DAY WAS OVERCAST PAUL KWIATKOWSKI

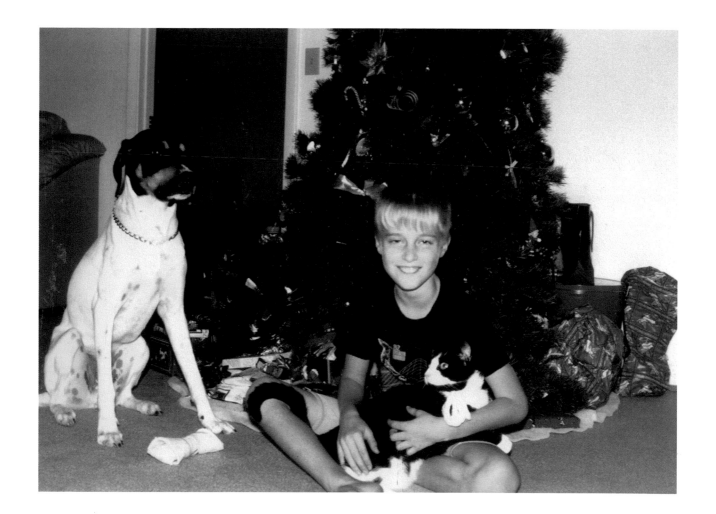

34

TRANSMISSION

Kevin Peter Hall, the actor who played the alien in *Predator*, died of AIDS from a contaminated blood transfusion.

Freddie Mercury, the vocalist of Queen, died of AIDS. At home, my mom played a steady rotation of Queen records.

Robert Reed, the father from *The Brady Bunch*, contracted HIV and died from colon cancer.

Anthony Perkins from *Psycho* died of AIDS.

The news was dominated by constant updates about a gaunt girl named Kimberly Bergalis. My family was riveted by her gradual death from AIDS, contracted from her dentist.

1992
RETARD RADIO
X

Every year there was a new version of this kid at school—the one who got singled out, the weakling, the faggot. It was like there was a defect in most kids' genes that solicited cruelty. There was no escaping it.

At my school, Cobain was that kid. We rode the school bus together. His real name was Toby but he insisted that we call him Cobain. I don't think he was even a Nirvana fan. Cobain was a mouth-breather with girly hips and thick glasses. Kids fucked with him mercilessly. Rednecks spit chewing tobacco at him, and jocks flicked his ears until they bled. Even the bottom feeders got theirs with cheap shots, like throwing batteries at the back of his head. Everyone got a piece.

Throughout the abuse, Cobain remained aloof and seemingly at ease. I envied that about him, but as an act of self-preservation, I never stood up for him. Instead, I made myself hate him for being weak. I imagined that if I became callous, the front would avert attention from myself. Sometimes it worked; sometimes there was no place to hide. Even then I knew to be grateful that, at worst, I was only invisible.

Cobain appeared to exist in some netherworld without parents and friends, without protection or even regard. He kept two belongings on him at all times: a pair of two-way radios and a frayed set of playing cards with naked girls on the back. He always had one radio clipped to his shorts and another pressed up against his ear. During the ride to school, he'd routinely lay out his playing cards, tit side up, tracing his finger over the breasts. I respected that he didn't care if people knew he was a perv.

Throughout the torment, he'd busy himself, adjusting the radio knobs and antennae until we arrived at school. I never knew what it was that he heard through the distorted frequencies, but he escaped us through the mysterious transmissions. It was his way of playing dead, a defense mechanism that earned him the nickname "Retard Radio."

On an unusually quiet morning, there was nowhere else to sit on the bus. We crammed in, three to a seat, beside Cobain. I was close enough to smell his burped-up sugary cereal. I guess the rednecks were worn out, because for the first time I could register crackling intonations from the radio.

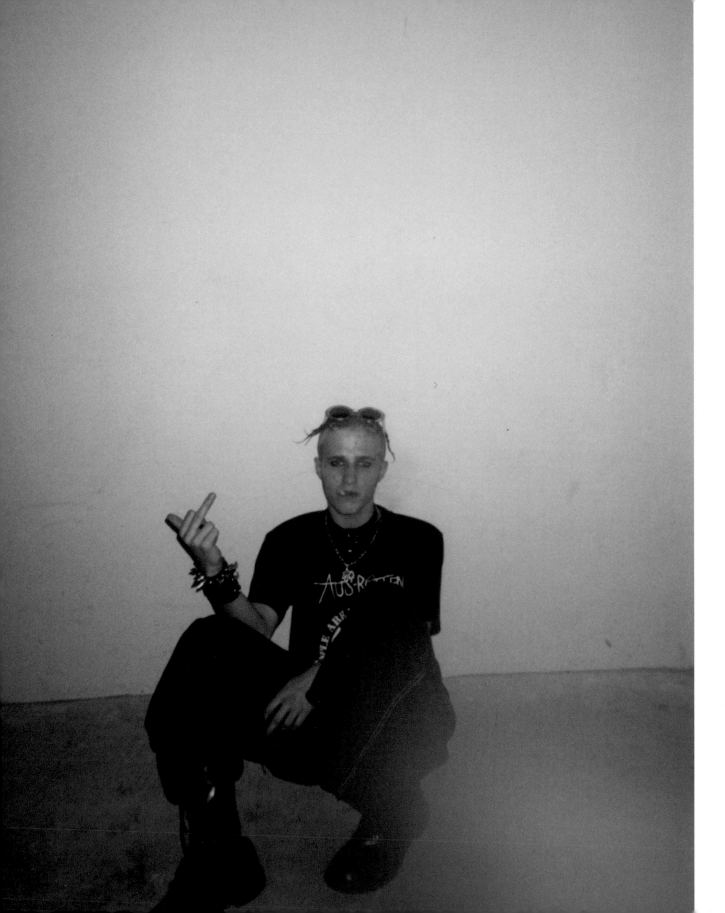

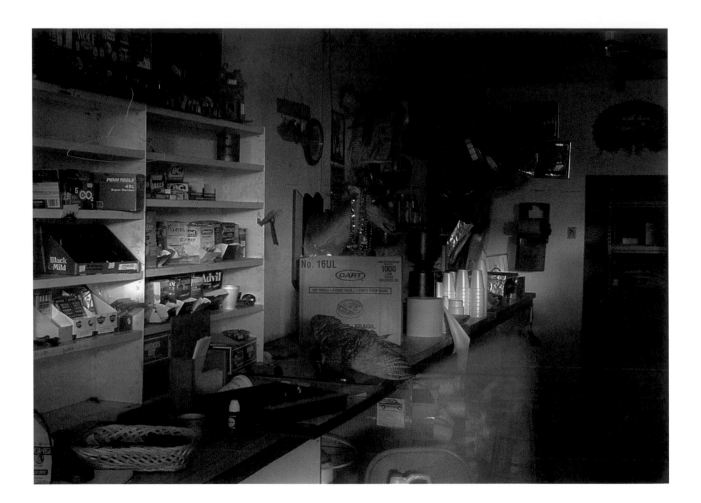

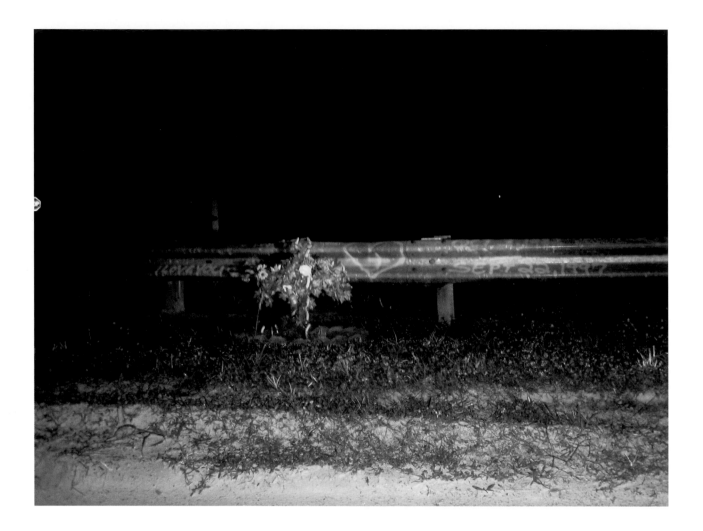

TRANSMISSION

In ninth grade she was the prettiest girl on my school bus. I had a huge crush on her but could never gather the courage to act on it. At the end of that year she died in a car accident where the bus would drop me off.

1993
KID TESTED,
MOTHER APPROVED
X

Hialeah Drive was fucked.

As kids we all had our own version of what went down on that small street. What happened to Hialeah Drive became our own urban legend. We spread rumors: The people living there were swingers, were involved with kiddie porn syndicates, were cult members with secret families trapped in the basement. In reality we never witnessed any evidence of orgies or demonic happenings. At most we saw a consistent rotation of unfamiliar cars parked out front and boarded-up windows that sealed Hialeah's inhabitants from us. In my opinion, the demise was a result of what happens to lonely, bored people and to families that never should have been.

I was alone, walking home down a dirt road after being dropped off by the school bus. The afternoon was sweltering, so I had stuffed my shirt into my backpack. Despite my town's notoriety for not being especially friendly, occasionally strangers would pull over to ask if I needed a ride home. The men probably had no interest in raping and killing me, but as a safety precaution, I always said no.

A white Honda Civic pulled up beside me. The driver was a woman in her late thirties with a deflated sandy brown perm. She excused herself for creeping up and said, "Hey hun, you're gonna burn up walking around like that. Need a ride home?"

She introduced herself as Hailey and, because she was a woman with a nasal voice that reminded me of my television dream girl Peg Bundy, I accepted the ride. I knew that there really wasn't much to her, aside from having a nice ass and pouty lips that seemed out of character on her narrow face. I remember thinking she wasn't especially sexy, just another mommy type, arguably a MILF.

Inside Hailey's car, the air conditioner was on high, cementing to the seats the smell of berry bubble gum and cigarette smoke. Hailey made a lot of nervous small talk between mentioning how jumpy she was about having a random kid in her car. I could tell by her accent that she was local, South Florida born and bred.

Throughout the short ride, I stared blankly ahead while sneaking obvious glances at her body. I remember it all to this day: She was wearing an aqua blue hospital scrub top, beige leggings, and a white linen skirt that was hiked up mid-thigh from driving. Nothing outright sexy—she looked like a clinic receptionist, but for some reason that made my mouth water.

She also took lot of deep breaths, continually reassuring herself that she shouldn't feel weird about helping a neighbor, that everything was fine and that I shouldn't worry.

I wasn't worried.

For weeks after, I cut class to compulsively jack
off in the handicap stall, thinking of Hailey.
I couldn't explain it. She was by no means
hotter than the girls at school—who I didn't
speak to—and it wasn't like she came onto me.
There had been no overt weirdness. Maybe
it was because I was a shy kid alone with a
woman who wasn't my mom or an aunt or a
teacher. Maybe I was just fourteen and horny.
Regardless, after that ride, I walked down that
same dirt road every day, slower than usual,
eyes peeled for a white Civic.

1993: KID TESTED, MOTHER APPROVED AND EVERY DAY WAS OVERCAST PAUL KWIATKOWSKI

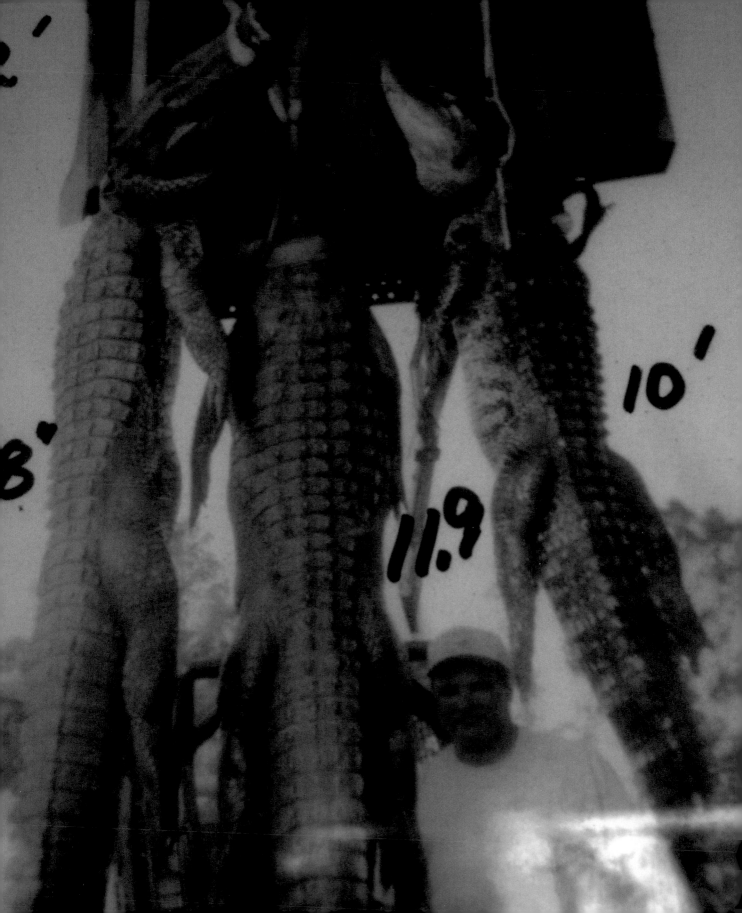

60

1993: KID TESTED, MOTHER APPROVED AND EVERY DAY WAS OVERCAST PAUL KWIATKOWSKI

PAUL KWIATKOWSKI AND EVERY DAY WAS OVERCAST **1993: KID TESTED, MOTHER APPROVED**

1993: KID TESTED, MOTHER APPROVED AND EVERY DAY WAS OVERCAST PAUL KWIATKOWSKI

TRANSMISSION

On weekends after hunting alligators, they'd butcher their catches in the garage. The creepiest part was glimpsing the dusty Bowflex standing in the corner like a mean S&M toy.

1994
LIONS
✕

In middle school I lived about a quarter mile away from Lion Country Safari, a drive-thru zoo where sedentary families could safely simulate safaris by watching chimps jerk off on the side of the road and clumsy lions climb up onto the hoods of their cars.

These giraffes, hyenas, and other transplanted safari animals roamed "freely" within a fenced-in perimeter, separated from the mainland by a canal enclosed by razor wire. Beyond the fence was a half mile of dense swampland.

At the time Will was my best friend. He was the kind of kid who had a religious rotation of three oversized metal-band t-shirts, compulsively tucked his hair behind his ears, and by ninth grade already sported two dreadful tattoos—one, barbed wire, and the other, a tribal panther I jokingly dubbed Milo. In his free time, Will harvested Colorado River toads purchased from a "holistic medicine" store. He'd siphon venom out of glands on their backs and mix it with Arizona Iced Tea to make a hallucinogenic mind fuck, a concoction that blunted faces into crude, featureless Popeye-looking masks.

We called it Toons.

Each day after school we would ride our bikes down veiny trails through the swamp. These narrow pathways were often streaked with the most random shit: a washing machine once used as target practice, bloody socks, feral dogs, boxes of burnt country-music tapes, used condoms, and, my favorite childhood discovery, an abandoned trailer.

The mobile home was choked by a mess of vines, tilted up at an angle by mangrove roots. The inside was half burnt and gutted, but most of the cabinets and linoleum flooring remained intact. Pushing deeper into the swamp, past the trailer, was a small clearing followed by another short path that led to the Walk Through Safari section.

Will and I smoked Toons-soaked weed before pedaling our Huffy bikes full speed through the Safari Maze and Dinosaur Park. My favorite of all these activities was coaching parrots at the Exotic Bird Aviary to say "suck my cock."

We made it a habit to tell our parents we were sleeping over at each other's house as an excuse to spend nights in the trailer. It was there I came across my most important childhood breakthrough: a kitchen cabinet full of porn. This was before the era of instant access Internet, back when finding a stash of weather-beaten porno magazines inside a dilapidated trailer was tantamount to actually getting laid. We spent many nights huddled around our flashlight, bleary-eyed, thoroughly

scanning each page, taking in detailed mental notes, and charting unrealistic expectations of what we hoped to experience one day.

Above the trailer door, we had fashioned a wind chime out of empty beer cans. Through-out the summer the cans had filled with water and became a breeding ground for mosquitoes, but they were flung up so high in the trees that they were impossible to get down.

Within a week a gauzy black cloud of mosquitoes muted the trailer.

On a night we both dropped Toons, my body became so riddled with insect bites that I got violently ill. When I turned my head, the swamp smeared into a dirty green blur.

This was my first bad trip.

I've had a few more since, but this one will always stand out as the most terrifying. I was already late for dinner with my family. I knew they would be pissed. I hyperventilated for nearly an hour waiting for abstract fumes of colors to turn solid, for shapes to rearrange themselves into something familiar, and for Will to stop looking like Eric Stoltz in *Mask*.

Will writhed over the dirty linoleum. His eyes lolled inside their sockets. He drooled, drift-lessly darting his tongue through a ripped page of porn. He slobbered through the dirty paper where the vagina should have been, speaking in

a nervous cartoon villain voice that confessed his mind and heart had been poisoned, that he'd been "envenomed," convinced that any-thing outside the swamp would have rotted, that if we left, nothing back home would be the way we remembered.

I knew this wasn't true and that we had to leave. I had been expected at home much earlier. For hours we panicked blindly, trudging through lacerating brush that whipped at our faces and shins. The heat lowered gnats into a constant fuzzy eye-level swarm.

By the time we found our way out, my parents had already called the police, who were waiting for us with the Lion Country Safari security at the KOA Campground section of the park.

We had been sniffed out.

As a deterrent to future intruding hooligans like ourselves, all points of entry to Lion Country Safari were thereafter blocked off with boulders and the trails filled in with logs. The trailer was torn down.

71

Months later, Will got involved with Nazi skinheads, landing himself in a juvenile detention center and becoming described as "medically complex" to his mother and teachers. Our friendship soon dissolved. In hindsight, Will indulged a lot of my worst ideas and made them seem okay. At the time I knew I shouldn't miss that but I did.

I had no distractions from myself; there were days spent alone, lying beneath an overpass, watching cars pass through the grated section. At dawn I aimlessly rode my bike, taking note that I hardly ever saw people on their lawns, in their patios, or on the sidewalk. Behind curtains, lights turned on and off, but I rarely saw as much as a shadow pass.

Mostly I heard the televised voices of people I considered to be more real than the ones I knew in real life.

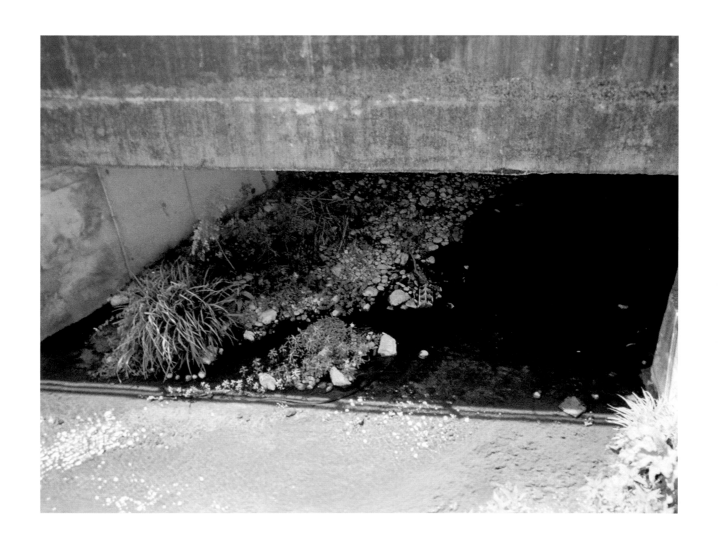

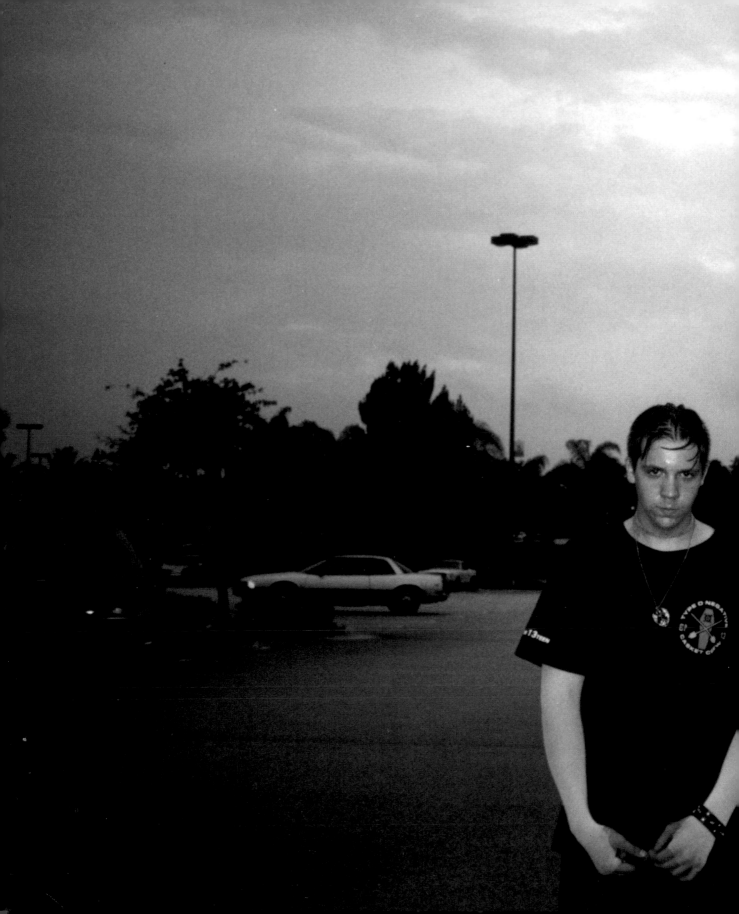

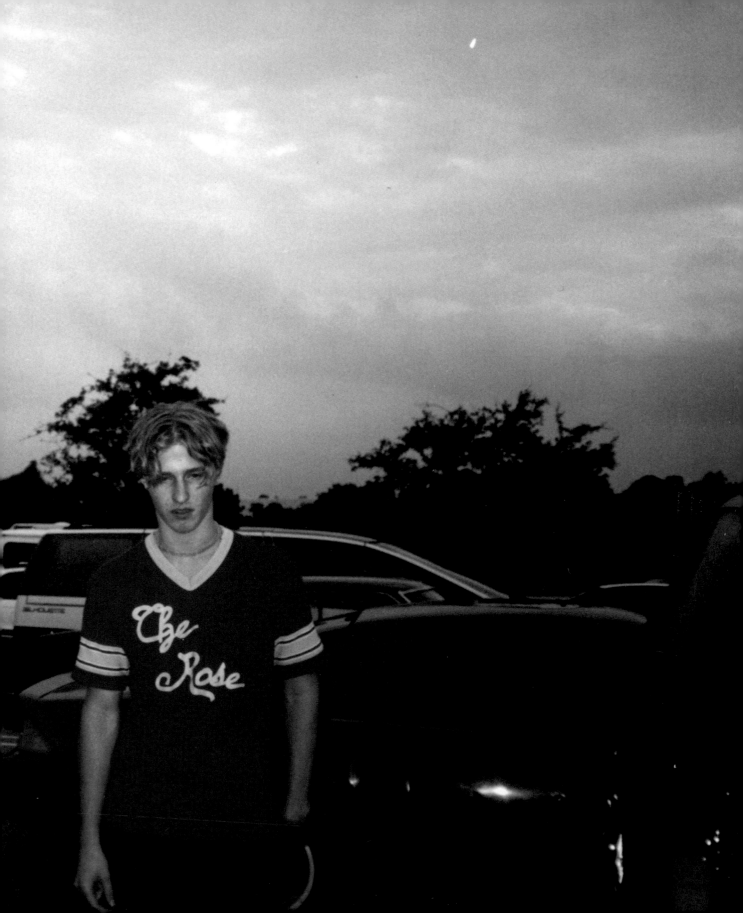

1994: LIONS AND EVERY DAY WAS OVERCAST PAUL KWIATKOWSKI

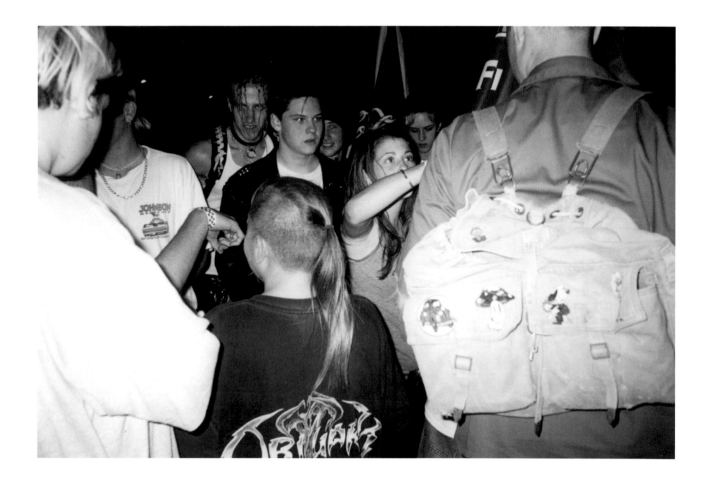

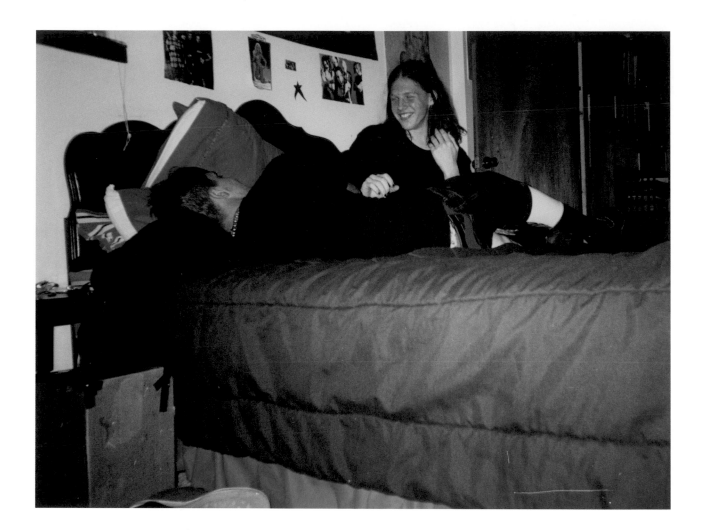

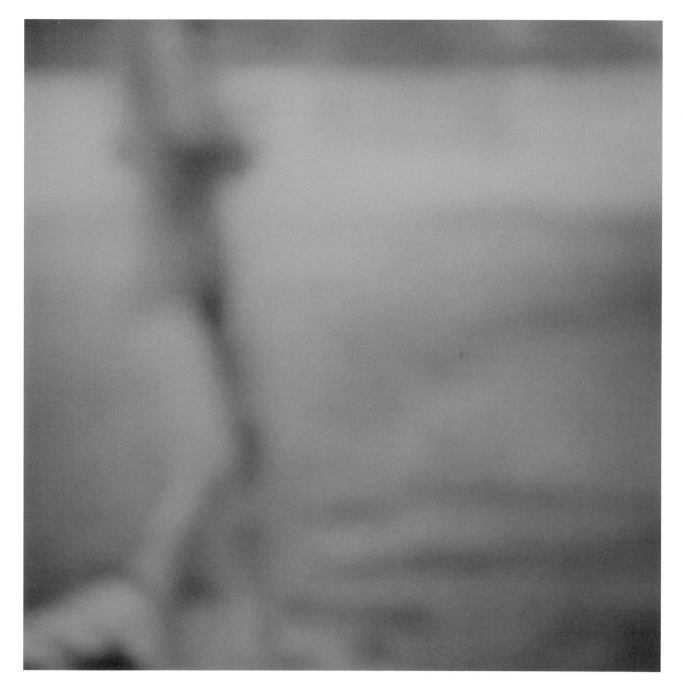

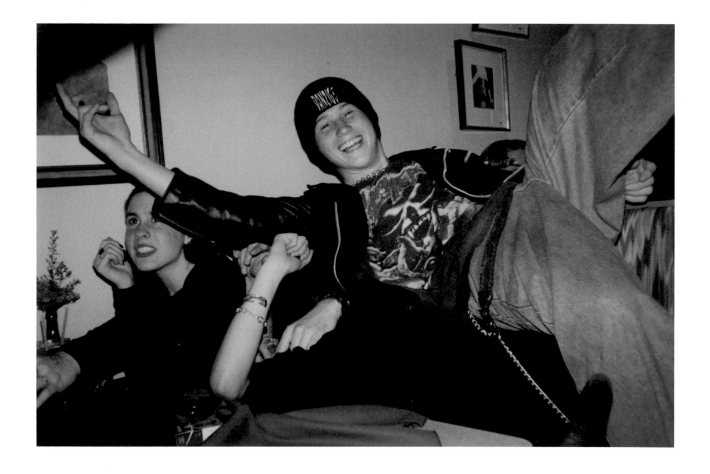

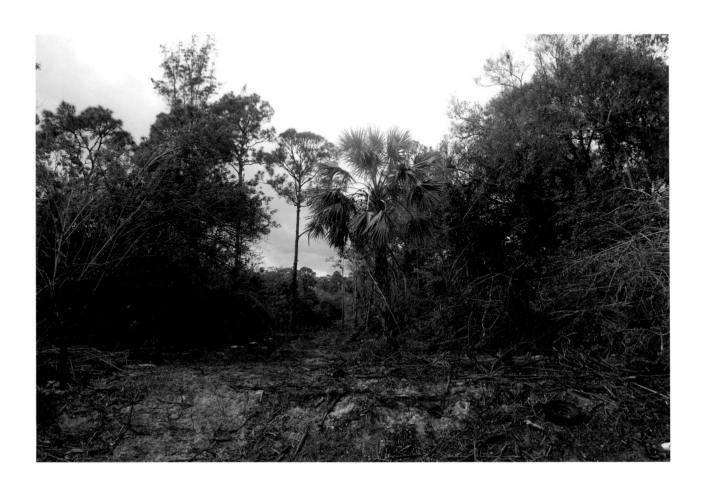

84

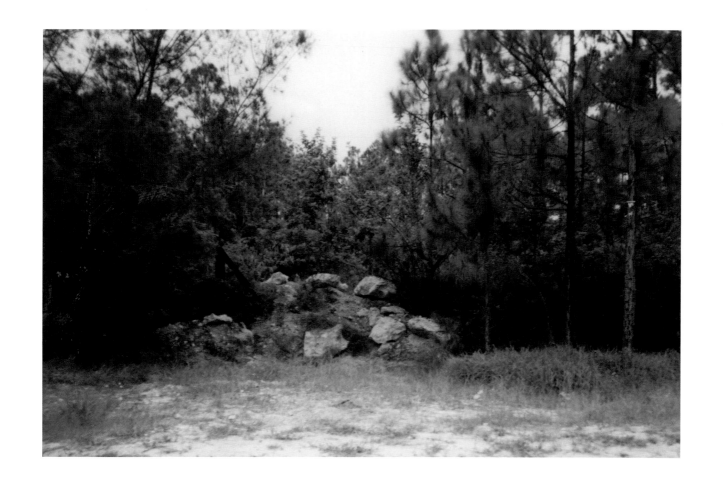

PAUL KWIATKOWSKI AND EVERY DAY WAS OVERCAST **1994: LIONS**

1994: LIONS AND EVERY DAY WAS OVERCAST PAUL KWIATKOWSKI

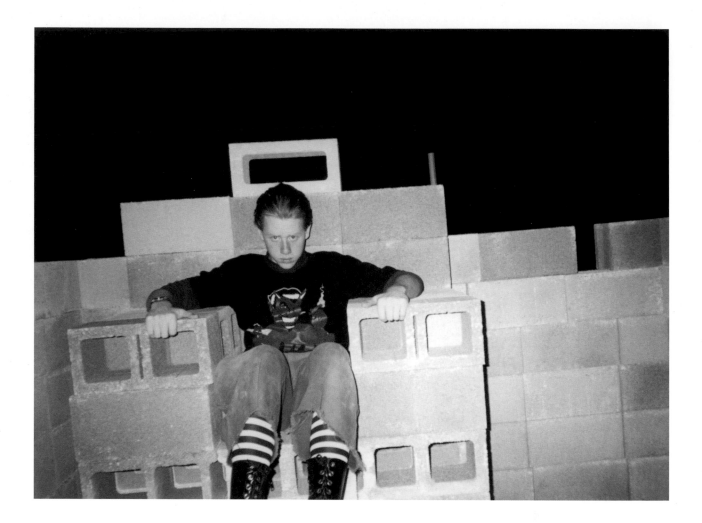

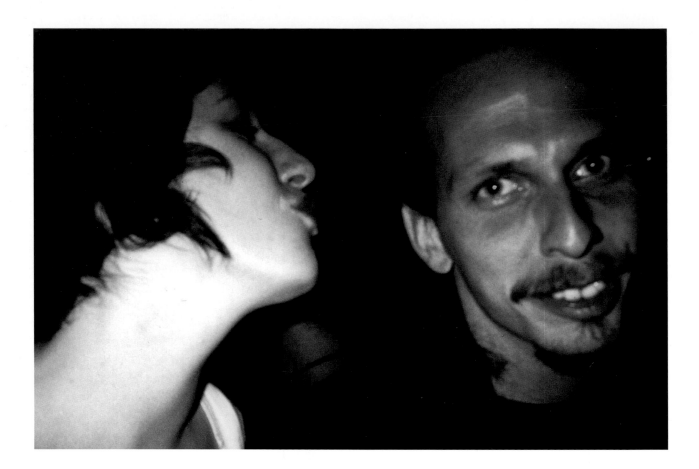

TRANSMISSION

He sold ecstasy, heroin, acid, and coke to punk high school kids. His house smelled like Vicks VapoRub. Over and over I watched him single out the sad loner girls, get them addicted to opiates, and make them his until absolutely no one wanted them.

1994
RETARD RADIO
PART II
✕

I was inside a Monte Carlo sitting beside Trick, a squirrelly nineteen-year-old white boy with gold teeth. That night he'd been driving us on an aimless search for a house party I wasn't sure was happening. Trick had one of those haircuts that was long on the top, tied in a ponytail, and shaved underneath. After a severe car accident, his posture was offset due to a broken collarbone that fused crooked. Afterward, he got by on a pretty sweet settlement and an endless OxyContin prescription.

Trick and I were never tight. To me he was just the older kid with nothing better to do than hook up my friends with beer and drugs in exchange for house parties where the potential was high for baiting teenage girls into sucking his dick for key bumps.

Whenever Trick drank too much, I'd catch him staring at me. His voice would quiver when he'd tell me things like, "Goddamn, you sound just like Darrell. From the side you even look like he did back in the day." And then he'd snap out of it, bleary eyed, apologizing to me with free blow that later provoked even more eerie sentiments followed by heated outbursts.

Darrell was his older brother, who died in the same car accident that had only scarred Trick with a slouch. I never met Darrell. All I'd seen of him were old framed photos Trick kept around his room. Darrell must've been in his mid-twenties when he died. From what I could tell, I guess we had similar deep-set blue eyes—

but even that was a stretch. Whatever resemblance we had, I believed that was the only reason Trick was nice to me.

Trick always made me wonder if people like him were aware that life was getting just a little too sweet in the wrong way. Most older guys I knew who turned teenage girls into damaged goods didn't last. I bet in the back of his mind Trick thought the same thing. I had a suspicion he secretly wished that he had died in that accident, not Darrell. I can't blame him. At least Darrell had a decent haircut and fucked girls his own age.

That night we stopped at the 7-Eleven to buy booze. Stepping inside was like being sucked into a void of white noise. The fluorescents were too bright and "Footsteps in the Dark" played through the tinny speakers. Hearing the actual song sampled in Ice Cube's "It Was a Good Day" disoriented me.

Parked beside the front window, next to a Mountain Dew display, was an old man in a heavy, motorized wheelchair. His leathery face was sunken. There was a clear tube exiting his nose and another from his crotch, both leading into a backpack slung over the wheelchair's handlebars.

94

Trick was outside pissing on the wall, clearly visible through the front window. Beyond him, I saw something gray and shapeless move across the parking lot. I squinted through the misty haze of street lamps. The diffused shape came into focus as it neared the store. Even though the figure was outside, still not entirely in sight, the gradual build of static could mean only one thing: Retard Radio.

It had been a few years since I last saw Cobain. He looked fatter and taller but still had the face of a damaged cherub. He was wearing a giant set of military headphones, connected to his coveted two-way radios. One was pointed up at a mess of electrical wires; the other was clipped on to his gym shorts, slightly tugging them down. There was something off-putting about his clumsy stagger, like he was overly medicated.

As Cobain approached the 7-Eleven, I saw Trick rush at him, cornering him back against the store's window. I thought about running out to defuse the situation, but instead I stood there, riveted, and watched.

Cobain stood still, silent and trembling, and Trick threw his weight behind a sucker punch to the eye. Cobain never cried out. He just stumbled and slapped against the window. It sounded like moist meat thumping tile.

Outside, Trick was standing over Cobain, panting, clenching his fist in restraint. Cobain was flush against the ground, arms at his sides, his face was swollen but the bruising hadn't started yet. I bent down to take a closer look. I remember feeling a weird kind of ownership over his body, like we had just hunted down the last of an extremely rare and hideous animal, the kind that later would be stored in a jar of formaldehyde for exhibition at oddity museums.

Cobain stayed motionless. His mouth froze into a twisted circle that curled his lip in above his teeth. The skin around Cobain's eye began to shift from a shiny opaque to baby blue. Because of his thick glasses it was hard to tell if he was faking hurt.

Trick picked up the dropped radio. He mockingly fumbled with the dials, then said, "Hey, faggot," into it; his voice crackled tiny and robotic from the other radio still clipped to Cobain's shorts—a move that made Trick laugh nervously. He tried covering it up with dumb jokes about pulling down his shorts to make sure he wasn't playing dead.

I could see the worry manifest on Trick's face. The times were catching up faster than I had hoped. Some modicum of morality had begun to set in. The good times were almost over.

Trick jammed the other radio into my chest like it was my turn to do something. I knew he only wanted to implicate me in the attack. Holding the walkie-talkie, I froze up, overwhelmed by the sound of radio static and buzzing lights fusing into an even drone. I thought of that quiet day on the school bus when I had sat beside Cobain. I remembered him trying to cut through those knotted bands of static, and now I had his radio.

I could have asked Trick why he attacked Cobain, but what was the point? I already knew what he'd say.

"If you want to hang out in the barbershop, expect a haircut." —Darrell, 1972–92

PAUL KWIATKOWSKI AND EVERY DAY WAS OVERCAST 1994: RETARD RADIO, PART II

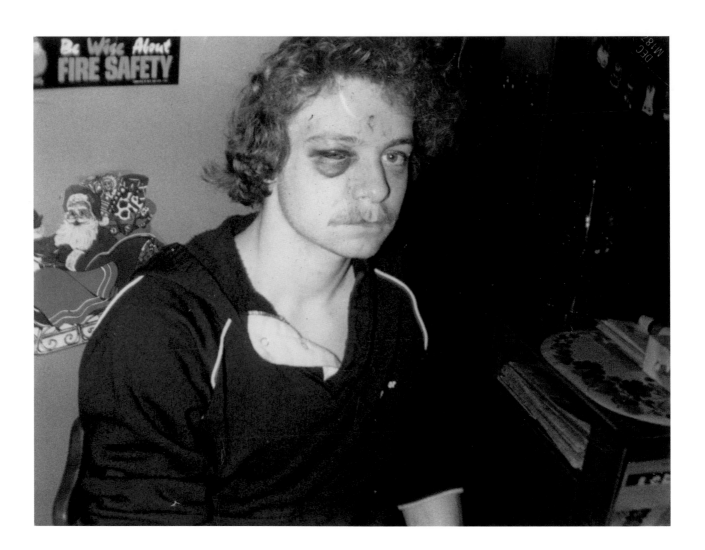

1994: RETARD RADIO, PART II AND EVERY DAY WAS OVERCAST PAUL KWIATKOWSKI

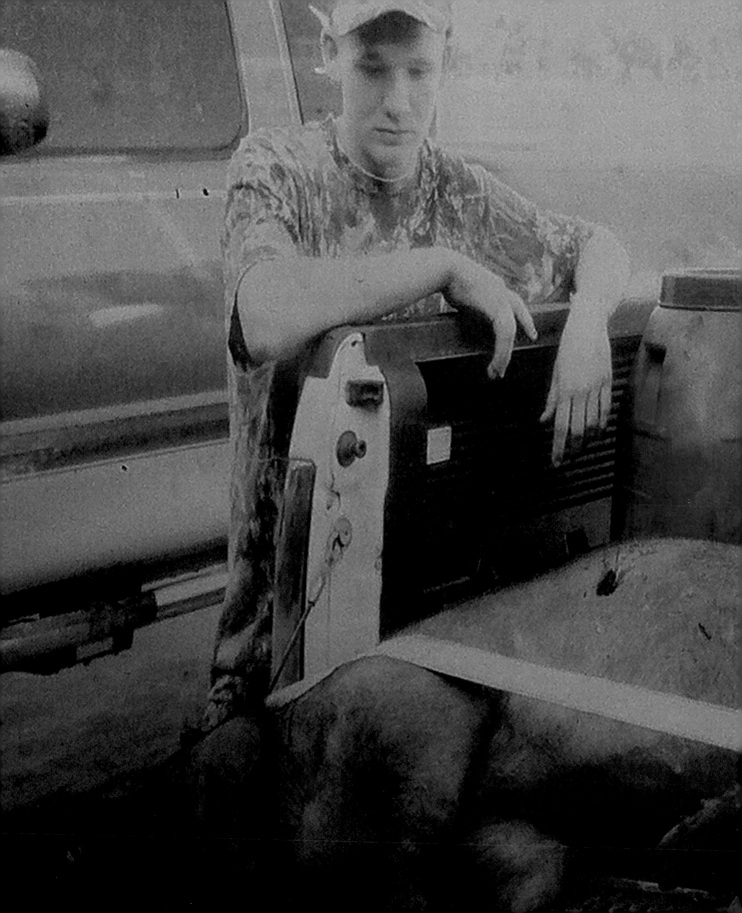

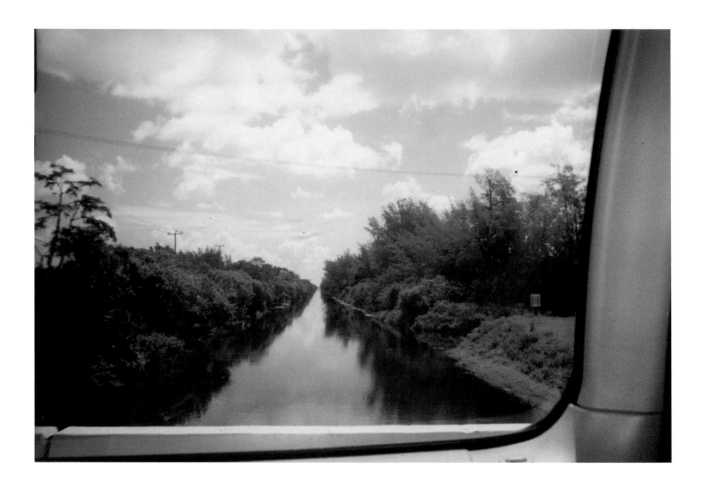

TRANSMISSION

Throughout seventh grade my buddy Will and I would cut class to ride our bikes out to this bridge that became our hangout spot. We'd sit on the railing, smoke cigarettes, eat Airheads, and make wishes by spitting into the canal. We could do this for hours and always wish for the same thing: to one day get a blow job.

1995
WINDOW PANES

✕

My first kiss happened between classes, in the middle of the hallway. I was fourteen. Her name was Sadie, and I'm pretty sure I wasn't her first. I kept my eyes open the entire time, reveling in every detail. To this day I still get a hard-on from the scent of watermelon lip gloss.

At fourteen Sadie was beautiful, bored, and entirely unequipped to handle the sudden, intense admiration of boys and men alike. It confused her; the more they admired her, the more she begged for their acceptance. At the time it made no sense that indifference and recklessness would become the keystones of my desire. Sadie had unknowingly set an off-putting precedent for what I would look for in women.

Her parents were white Puerto Ricans. They lived in a turquoise duplex with white trim, counterbalanced by a giant pencil-thin palm tree towering next to it. Their house was simultaneously modern and decayed, like if you scraped off the paint, there'd be something waterlogged and fleshy underneath.

Sadie had an uncle named Ricardo. He lived in a walk-in-closet-sized guesthouse in the backyard. He worked at the fish market, and anything he touched smelled briny. For extra cash, he raised rabbits in the garden shed. He'd sell them to butchers and pet stores. Sadie couldn't stand Ricardo, but she adored his rabbits—and, aside from drugs, they were the only things that made her voice break.

It was Sunday afternoon, and I was at Sadie's house. We were floating on an inflatable alligator in a small assemble-it-yourself pool, passing between us a poorly rolled joint. Sadie asked if I was curious to see Ricardo's rabbit coop. I didn't give a fuck about rabbits, but the opportunity to potentially hook up had to be seized—aside from that one kiss in the hallway, I hadn't gotten any further. I was stuck at first base, too timid to make a move. To compensate for being a pussy, I constantly tried to impress her. I adopted the things she liked most—namely drugs. I even pretended to give a fuck about Sublime.

The coop was dusty and dark. The air smelled earthy, like rabbit shit and fish. Most of the rabbits were stuffed into rows of small wire cages. A few sat motionless on the floor. I was unsure if they were alive. Just peeking in was enough to devastate Sadie. I hugged her and offered my shoulder to cry on. I made sure to position my crotch away from her so that she couldn't feel my hard-on brushing against her leg.

Every Sunday when Ricardo was working at the marina, we stole a rabbit. A half hour away from where we lived, we'd sail them on pizza boxes bound with duct tape to a small island at the intersection of two canals. After a few months, we imagined the island would be teeming with rabbits. When the tide lowered, we'd drop acid and wade over.

Sadie was into the plan. We ferried eleven rabbits, with only one failed attempt. From shore, the island looked like a mass of mangrove trees woven into a pile of congealed peat moss and canal debris.

Sadie scored a gelatin form of acid called Window Pane. Held in a thin square of tin foil, each hit looked like a purple reptilian scale. I stared at the tiny innocuous pyramids, half expecting wicked green fumes to rise up from them. Sadie split the halves then pushed the strip into her mouth. Not wanting to risk losing her respect, I made sure she saw me drop the entire other half. I knew she'd like me more if I cared less. The gel tab stuck to the upper ridges of my mouth, like a communion wafer.

I liked the way Sadie made simple things seem exciting. I thought of her as one of those blessed people to whom bad things never happen. Life never seemed to punish the beautiful. I took comfort in thinking that if something happened to me, it would happen to her as well.

In Belle Glade, the next town over, Haitian migrants slashed and burned the sugarcane fields. Black flakes of ash fluttered down, flavoring the air like dirty cotton candy. At the canal's base, I lifted a torn section of the fence. We slid through and ambled on the edges of our feet, walking sideways along the canal's loose embankment until we reached solid ground. Our journey was hushed, layered with the buzzing grind of heat, insects, gators, and frogs.

The acid kicked in. Starting at the base of my skull, a gradual tingling began. The sensation trickled down my vertebrae, flowing outward then pooling in my heels. Each inhaled breath dislodged something fetid and heavy forming deep within my chest.

Sadie quietly marched ahead. I watched her ass swish side to side until my mouth watered. I wanted to catch up, make her laugh, and take her hand, but I couldn't bring myself to even try. It drove me crazy that simple things like showing comfort and affection came so effortlessly to most people. Part of me hoped that if I did enough acid, those inhibiting elements of my personality would fracture.

I needed a breather.

We sat Indian style for a while, watching two dragonflies fuck in midair, mesmerized by the hazy neon colors cast off their wings. At dusk, the swamp warped and striated into wispy streaks. My skin felt detached and calloused as though it had doubled in size and begun to shed off my body. I remember being afraid to look down and see lumps of skin bunched up around my wrists and ankles.

The island appeared much closer to the shore than I remembered. The murky water was knee deep, low enough for us to trudge over as planned. After the initial excitement of making it to shore, we scoured the island looking for the rabbits. All we found were bits of bone

surrounded by eleven oily brown stains seeped into the ash-blackened sand.

I spotted a rabbit, half her body peeking out from a mess of mangrove roots. I picked up the malnourished animal, its emaciated legs dangling useless over my arm. I petted the slick wet fur and the rabbit gasped and struggled out of my arms. I dropped it. The rabbit landed on its side, stunned, mouthing agony through dirty spittle.

Sadie was flushed. She looked crumpled. I was afraid to touch her. This was not the way things were supposed to go. I told her that everything was going to be okay. I told her the bunnies were in a better place now. She moved away from me, her back turned. At that moment, I knew that she truly hated me and rightfully so. I had marooned us on that small hell.

As the tide rose, she sat perfectly still, occasionally trembling, staring out at the giant plume of smoke building on the horizon. I looked away, dumbly spacing out instead of hugging her like I know I should have. I wanted to say something reassuring but nothing came out. I was sporadically going in and out of blackout mode. Moving my head made everything in sight bleed together like watery wet paint. Each time I'd come back to reality only to force out an uncomfortable laugh.

And then Sadie was gone. She had left without me. I was alone.

At least no one else had to witness what followed. My last memories of the night were of leaning against a giant mangrove, looking up at a starless sky, trying not to puke. This time I couldn't fool myself out of the situation. There was no way Sadie was ever going to fuck me, or even blow me. I would stay a social leper, a virgin for life.

Before trudging back home, I closed my eyes and zeroed in on my breath. I imagined falling, waiting for impact, falsely assured that this would all be over and I would never again fall for something I couldn't walk away from.

108

AND EVERY DAY WAS OVERCAST PAUL KWIATKOWSKI

114

1995: WINDOW PANES AND EVERY DAY WAS OVERCAST PAUL KWIATKOWSKI

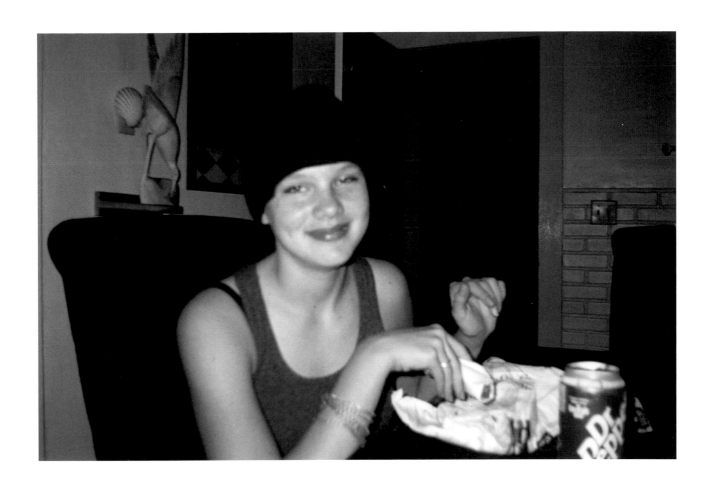

119

FIRST SIGNAL

✕

I couldn't sleep. At night I obsessed over what happened to Cobain at the 7-Eleven. I only dreamt of wandering through empty places—vacant outlet malls, warehouse units, the DMV, stationery stores, clinics, classrooms, Goodwill, luncheons, Pier One Imports, frozen food aisles. All places I didn't want to be. No one was even chasing me. I was stuck, fucking off, begging for escape. Too often I woke up travel weary, stupid-eyed in the mirror.

Since the attack, Cobain hadn't shown up at school. I thought of asking around, hoping one of my classmates had heard about his whereabouts, but no one even noticed he was gone. It occurred to me that on the off chance Cobain had been killed that night, or in the even more unlikely scenario that he'd been abducted by a third party, I didn't want to bring attention to myself by asking questions.

Cobain hadn't bled heavily, but Trick hit him full force. Afterward he wanted me to help drag Cobain's body to the side of the store, away from the heavily lit parking lot. There was no way I was going to touch him. I didn't even want to be there. Trick called me a fag and said he'd been wrong about me, I'd never be anything like Darrell. We never spoke to each other again.

I routinely checked the local missing persons reports but found nothing about Cobain. I even returned to the 7-Eleven, but there was nothing there, not even bloodstains.

Cobain had no friends. It was impossible to find out where he lived. Involving police was a stupid idea. If they didn't lock me up as an accomplice, Trick would hunt me down. Either way I was fucked, so I waited it out.

I kept Cobain's radio in my room buried beneath a growing pile of laundry. I thought it would bring bad luck to have it in plain sight. I could totally see some *Hellraiser*-type shit happening, like it opening up and ripping me out of existence.

Worse than my guilt and fear was the relief I felt. I told myself that his evaporation was a small death that had brought him to a better place.

I might have been turning into a monster. I went through the motions.

 More than usual, I kept to myself.

PAUL KWIATKOWSKI AND EVERY DAY WAS OVERCAST 1995: FIRST SIGNAL

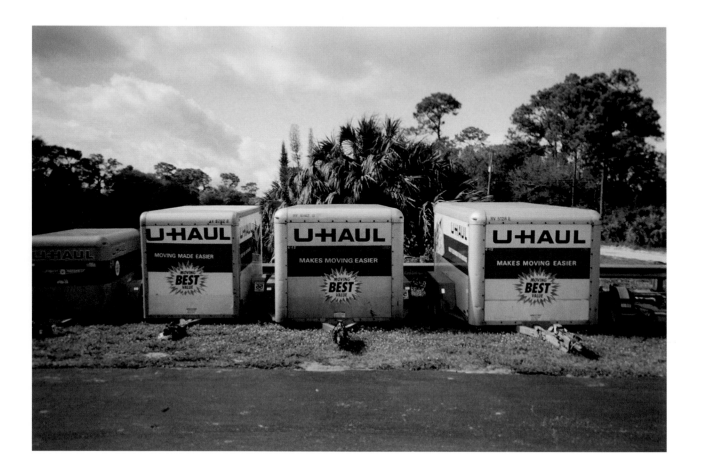

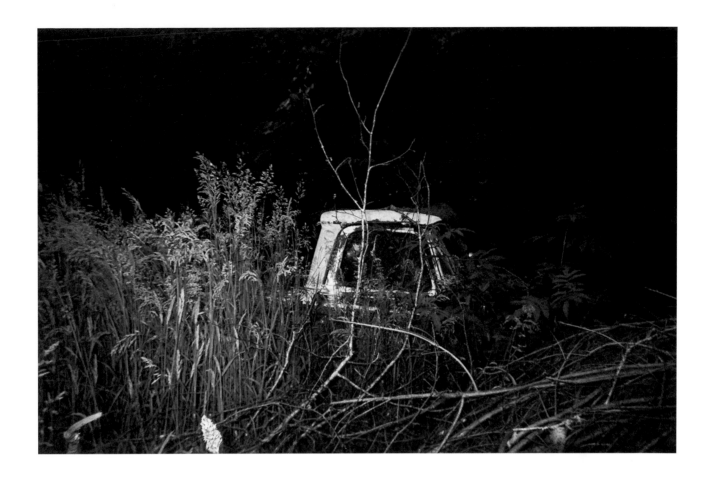

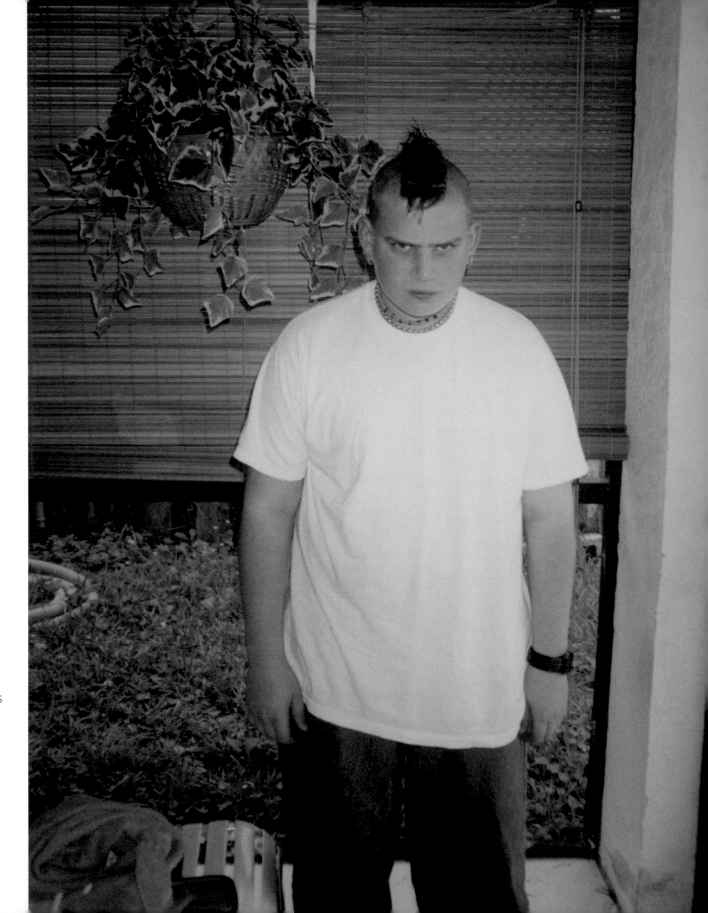

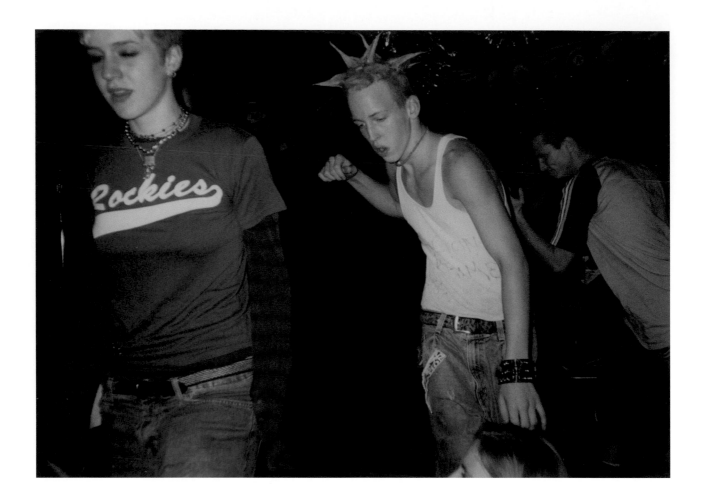

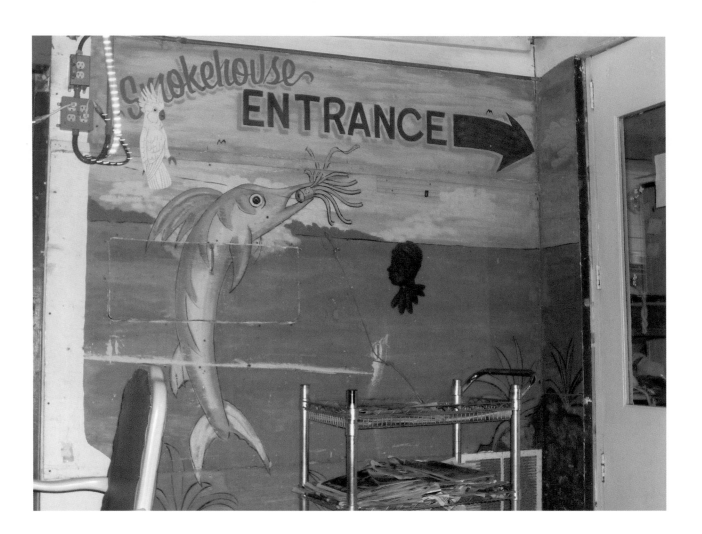

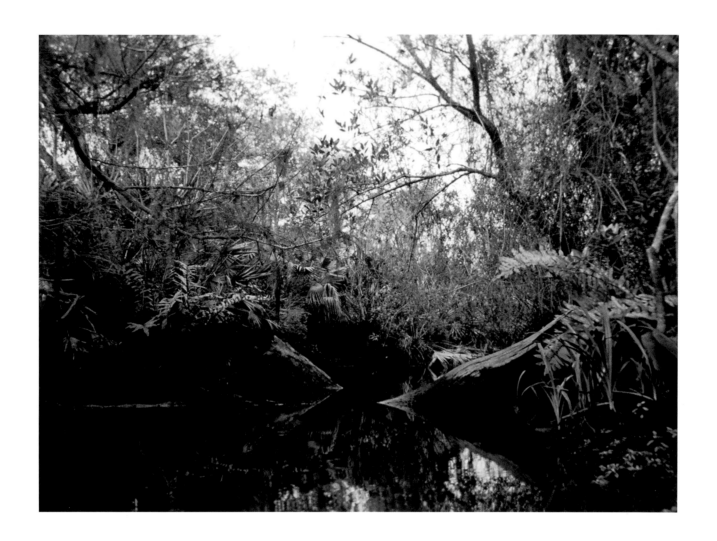

PAUL KWIATKOWSKI AND EVERY DAY WAS OVERCAST **1995: FIRST SIGNAL**

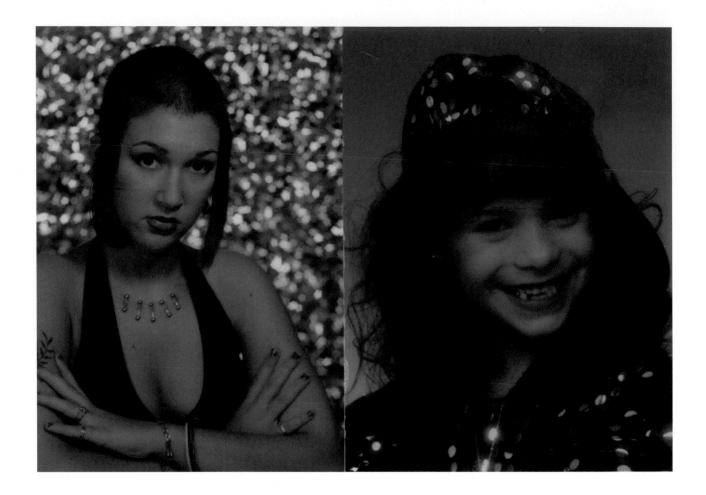

132

AND EVERY DAY WAS OVERCAST

PAUL KWIATKOWSKI

TRANSMISSION

Riley and Vanessa were best friends. Word around school was that they kept a shoebox of things that were important to their friendship. Inside were their first tampons, the condoms that took their virginity, stacks of photo-booth photos, an old piece of chewing gum they shared for a week, and a tied bundle of each other's pubes. I secretly thought the box idea was really cool.

1996
ACID DANCER
✕

The Ortega home was a suburban Florida duplex-turned-squat, replete with turquoise trim, white walls, and two outdoor refrigerators—one in the garage and one on the patio. The Ortegas were a devolved version of a sitcom family: Manny (age eighteen), Ty (fourteen), and Phil (thirteen); an older sister, Nicole (nineteen); and their mother, Tina. No dad.

The youngest brother slept in a tepee in the living room. The older ones worked at fast food joints, selling raver drugs to high school kids out of the drive-thru windows. In the eyes of our parents, Tina constituted "adult supervision." She let us run wild. She even did drugs with us. Her logic was that she would rather have her children and their friends do drugs at home with her than out on the streets. I think Tina just wanted to feel like part of her own family.

Nicole never hung out. Normally she stayed cloistered inside her room. I secretly had a crush on her, but she referred to me as "one of her brother's little friends" or, worse yet, "Worm." Nicole aspired to be a Rockette or a Vegas showgirl. I had no idea what either of those ambitions entailed other than being a hot leggy lady with lots of teeth who pranced around to holiday show tunes marketed to the elderly with a bunch of other identical girls. I knew this because West Palm Beach was swamped with retirement homes. The elderly and their puzzling ways were an ominous presence in my life.

Sunday morning at the Ortega house, I was one of the stoned kids, paralyzed on the couch watching my friends play Super Nintendo. Not giving a fuck who won. The oldest Ortega boy, Manny, had a best friend named Scott who was an instigative rube that, when drunk, tried to convince us to shave our heads. He once forced a thirteen-year-old boy to snort a giant line of K. The kid freaked out so badly he ran out of the house, narrowly avoiding being hit by a car before being found by his sister, crying, stranded, and confused at a nearby strip mall. Scott didn't like me, straight up. He'd antagonize me incessantly, trying to pick a fight. I always walked away humbled, because I was afraid of losing.

On the patio, Scott and a few older kids were beer bonging. I could tell by his exaggerated gestures that he was showing off. Through the screen door we made eye contact. Sneering drunkenly, he whispered something to the other guys. The heat was directed at me. Hiding out inside Nicole's room was my only plan of escape.

The soft throb of trance music leaked from beneath Nicole's door. I stopped short of knocking to allow her intoxicating, feminine scent to settle into my lungs. Equal parts AquaNet, clove cigarettes, and gas-station incense, it was an ocean I'd be content to drown in.

After minimal pleading, Nicole let me in
because she also hated Scott. She said that I
could hang out if I didn't talk. I could tell she
got a kick out of how intimidated I was. She
was taking mushrooms and wanted to practice
dance stuff. I remember her telling me that
tripping was how she concentrated in that
house. She said it was the only way she could
truly be alone.

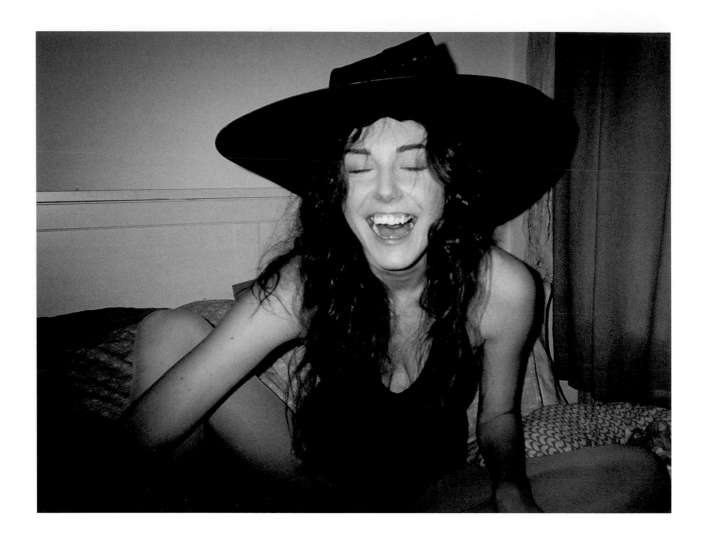

1996: ACID DANCER AND EVERY DAY WAS OVERCAST PAUL KWIATKOWSKI

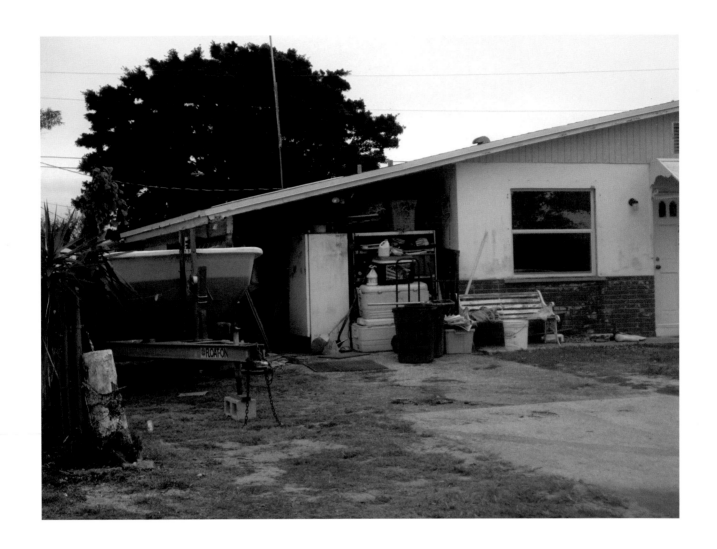

PAUL KWIATKOWSKI　　　AND EVERY DAY WAS OVERCAST　　　**1996: ACID DANCER**

143

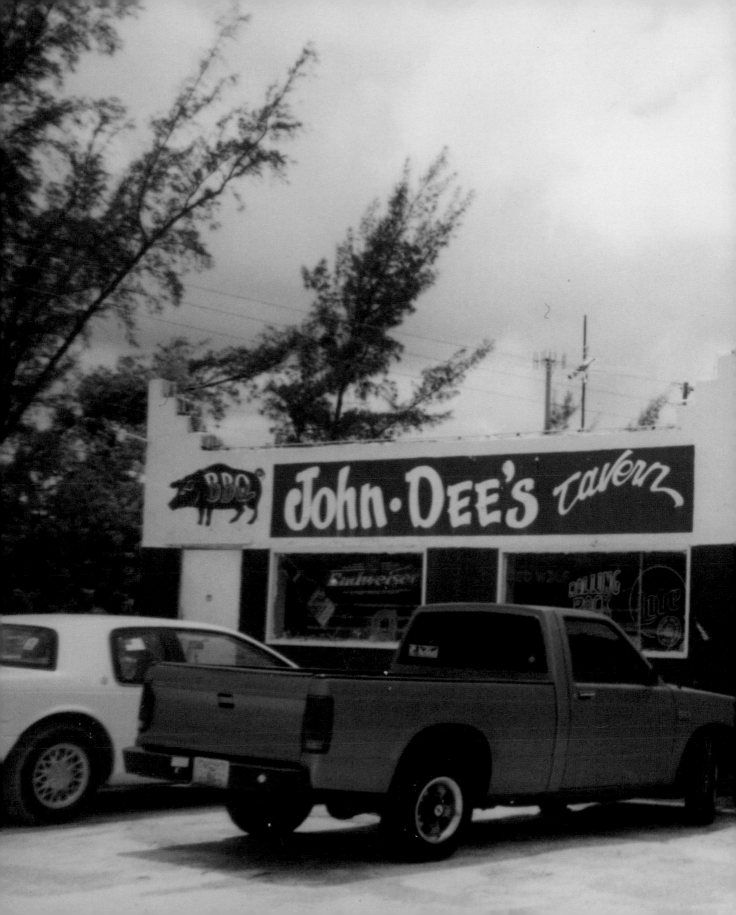

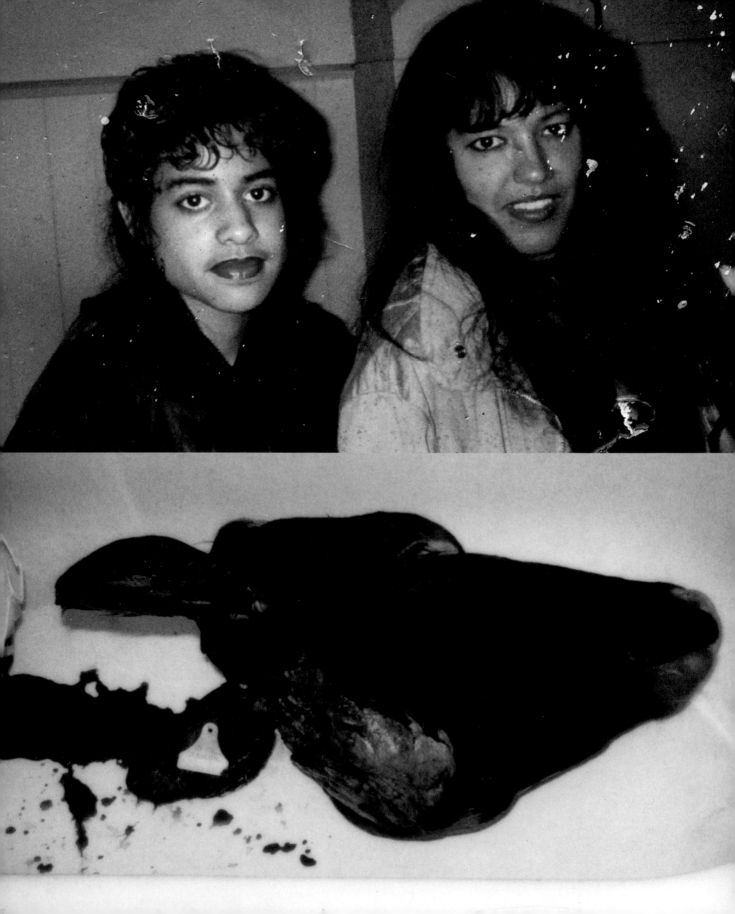

TRANSMISSION

Christina and Lisa were sisters who sold coke, gel tabs, and random pills from their apartment. Their place shared a ventilation system with John Dee's Tavern, which tarnished anything fabric or edible with the scent of barbecue sauce and coagulated pig/cow blood. After Lisa had a stillborn at a house party, they both disappeared. No one knew where to, but we assumed they went to live with their mother in Miami. Before I knew they left, we went to check on them. The door wasn't locked, and a majority of their stuff was still in the apartment. Inside their bathroom I found an old photo of them in the medicine cabinet and a cow's head in the bathtub. A week later John Dee's Tavern extended their kitchen into what was once Christina and Lisa's apartment.

1996
FACE BREAKER

✕

Face Breaker was a scrawny redhead who exclusively wore white hoodies, flared jeans that sagged around her ass, and giant gold hoop earrings. She slicked back her hair into a ponytail so tight it glistened under park floodlights. We called her Face Breaker because she'd get drunk and make out with any guy, no matter how gross. Her drink of choice was mixed fruit flavor St. Ides.

She and her best friend Jalenne were inseparable. Every day after school and all day during the weekend, they'd hang out at the picnic table by their housing development's community pool, chain-smoking cloves and provocatively sucking on Blow Pops. Over summer break, they stayed anchored to that bench, only leaving when the floodlights went out at midnight.

In the morning I'd analyze the tabletop for new scrawl. I'd investigate for any relatable evidence that I could use to integrate myself into their world, but there were never leads. At most there were etched rows of serrated lines spelling out the initials of boys I didn't know or care about, which were surrounded by generic girly symbols, like hearts and stars. It might as well have been hieroglyphics.

During my repeated year of first grade, Jalenne was my best friend and neighbor. She was a year older than me. Because of stupid zoning regulations, we were assigned to different schools. I got bused to the ghetto; she got bused to the suburbs. After school we'd walk home together from our separate bus stops. At the time I prided myself on always having a pretty girl around. Our favorite game was riding bikes side by side as fast as possible, while holding hands. The goal was not to let go and not to fall. It became a bloody game that went on for too long. By the end of summer our knees were scarred pastiches of scabs, injuries that became suspect among our parents. I only endured the pain for an opportunity to be close.

As childhood passed, Jalenne took interest in other things and people. We'd become estranged. I'd see her only in passing, always with Face Breaker at her side, hanging out at the picnic table. Occasionally I'd nod. At first Jalenne would nod back. Over time even that ceased. I wondered if and how she remembered me. It seemed that childhood friendships like ours were quickly erased from the minds of teenage girls.

To further complicate the situation, I developed a sudden, intense, and problematic desire to lose my virginity to Face Breaker. I couldn't justify, understand, or articulate what twisted part of my psyche wanted anything to do with that ginger hood rat who probably would end up fucking every scumbag in school before moving on to older scumbags, like Trick.

But that winter break something changed; Santa had been kind to Face Breaker. Her ass began to fill in those saggy flared jeans.

154

Jalenne, initially the hotter of the two, was not as fortunate. Her body began to mirror the stout, slightly oafish figure of her mother. Even more upsetting, her ass began to flatten. It was a cruel lesson in biological predestination. Lucky for me, there was a silver lining because at that moment I realized something critical about my identity: I was an ass man.

Instead of reveling in my vacation time away from school, I squandered the days jacking off and obsessing over how mindlessly attracted I was to Face Breaker and her juicy new ass. It was sick—even her translucent freckly pale skin seemed to shimmer when she would sweat. I couldn't explain it. I wanted her so badly that I hated myself for it.

Aside from the disastrous aftermath of my first kiss, I had made zero progress with girls. But what fucked me up most was that, even if I had a chance, I wouldn't know what to do with it. Face Breaker had experience, lots of it. I had shit. I made out with one girl for a few seconds, and I probably sucked at it.

It was a discomforting realization thinking about the amount of energy I wasted being shy and ignoring social details that could've made me more likable. It would be a matter of days before the New Year and school would start again. I didn't want to go back to being the same timid boy as before. It killed me to imagine Face Breaker being defiled by someone else. There were only two days left of vacation.

That was hardly enough time to conjure up an interesting angle with which to approach Face Breaker or Jalenne. My brain produced nothing of relevance. Talking was not my forte. I had to come up with an alternate method. I raided a long forgotten bottle of my father's vodka that had been in the freezer for years. I chugged half, puked up some in my mouth, then to be safe, refilled the bottle with water. My stomach burned as I stumbled toward the picnic table, wincing through a dirty head rush.

I put a little too much weight into sitting down, shifting the table, right away setting a bumbling tone. Neither acknowledged my presence. Their backs stayed turned away from me. Jalenne acted annoyed. She spoke in a shrill voice, like I wasn't there. They rattled on about boys with fresh nicknames, about which ones were in gangs, about which ones Face Breaker would hook up with. They gossiped about which girls had sucked a dick, which of those girls swallowed, and what they imagined cum tasted like. Jalenne said rotten papaya. Face Breaker predicted something sweet and tangy. Both seemed eager to find out.

They were obviously trying to drive me away. I sat there pretending not to be listening, like I had my own agenda and simply happened to be sitting there. The situation was pathetic. I busied myself by carving a pentagram into the wood with my keys. Face Breaker complained about how hard it was to convince gas station clerks to sell them St. Ides. She couldn't wait

to start hanging out with seniors, who could easily get booze and drive them around.

Overhearing that last line kick-started my brain. I had a better plan.

Dan was a homeless drifter. I'd see him panhandling at stoplights all the time, his cardboard sign always the same: *Broke and Busted*. My friends and I knew he lived in a makeshift tent in the woods, past a dead-end drive. We used to dare one another to steal porn from inside Dan's tent while he was out panhandling. I remember thinking that Dan had a pretty nice setup for a bum. But his taste in porn was questionable. He was mostly into interracial shit and hardcore foreign titles, like *Thai Girl Cum Guzzlers*, *Cancer Slut's Last Wish*, and *XXXtreme Anal Punishment*.

Aside from the ubiquitous porn collection, his tent included a sleeping bag covered by a mosquito net, canned food, mouthwash, a battery-powered hot plate, shovels, and a messy pile of yellowed sci-fi novels.

Passed-down hearsay among my insular circle of friends was that Dan would buy teenage boys alcohol under one condition: they show him their cocks. I had yet to experience this transaction. It would no doubt prove to be an unsettling experience, I mused, but I'd have to overcome my timidity to realize the bigger picture. After all, this wasn't just about buying St. Ides for Face Breaker, it was

about finally killing off that shy person I'd stagnated into.

If my plan went accordingly, by that evening I could get Face Breaker drunk enough to hook up with me. Dan was my only hope. I shot off the bench, told the girls I'd be back (they ignored me), ran home, and grabbed my bike. During the day, I knew that if Dan wasn't at the stoplights, there was only one other place he'd be.

Dan was posted up by the gas station men's room. He had a bottle of green mouthwash poking out his back pocket. When he saw me approaching, he took a swig of the mouthwash and without swishing spat it out. The implications gave me chills.

I'd never seen Dan up close. His jaw line was chewed up with acne scars and his sinewy arms were overly tanned. Even though his clothes were relatively clean, everything else about him looked cantankerous. He wore cargo shorts, sandals, a shark-tooth necklace with an airbrushed shirt of a sailfish. He almost looked like he could be a regular dude, like some poor kid's shitty dad.

I didn't know if there was some sort of hand signal I should give Dan so that he knew that I wanted him to buy me alcohol in exchange for a glimpse of my dick. At a loss for proper code, I gave him a head nod. He acknowledged, motioning for me to follow him around the

156

corner behind the back dumpster. Unsure of what to do next, I stood very still waiting for another cue.

Dan crossed his arms and said, "Come on bro, stop wasting my time. Let me see that mother-fucker." I was baffled. Actually I don't really know what I thought. I guess I imagined he'd be nicer or something. But no, Dan was a straight shooter.

I pulled down my pants mid-thigh, flashing him a solid look at my cock. Aside from pissing in public, I'd never allowed my penis to hang so freely. The air around it felt icy hot. I knew that moment would be one of the final death throes of my former self.

Dan said, "Keep it out until I say." That's when two unexpected things happened: first, I start-ed to get a mild, involuntary hard-on (this had happened to me once before during a medical checkup), and second—even more disturbing than my body's inability to control itself—was that Dan's eyes welled up and he choked up, like he was about to cry. I quickly slipped my dick back into my pants. Dan snatched the $20 out of my hand and muttered, "Figures."

As he stomped into the store, I yelled, "Just remember the St. Ides!"

It was early evening. The sky was cut up with neon swaths of pink and purple over dark blue. Naturally Face Breaker and Jalenne stayed loyal to their spot. This time I didn't sit down behind them. I didn't even bother coming up with anything cool to say. I didn't need to. Still panting from the bike ride over, I stood before them and revealed a backpack full of St. Ides. It was the first time Face Breaker ever smiled at me. She even took the Blow Pop out of her mouth. Jalenne, on the other hand, was visibly unhappy. She might have been jealous her friend had taken a shine to me, but fuck her. It was ridiculous how perfect Face Breaker's smile made everything.

It was past community pool hours so we had to jump the fence to get inside. The pool bathrooms were the perfect place to hide. The locked door was easily picked with a bobby pin or credit card and could be locked from the inside. My friends and I did most of our drinking and drugging there.

Since the afternoon, I had noticed that both their breasts looked bigger than I had remem-bered. They were slightly pointy and held too firmly in place on their chests. Realizing that they had recently stuffed them comforted me: I wasn't the only insecure one. Initially, it was very awkward. There was very little talking as we all guzzled down the first round of our giant, saccharine, artificially flavored malt liquor. St. Ides tasted like melted candy mixed with cheap beer and ghetto soda flavors—but whatever, they loved it.

157

My plan began to work. Face Breaker was talking to me. She even laughed at my favorite dead baby joke:

"What's the difference between a dead baby and a rock?"

"What?"

"You can't fuck a rock."

Jalenne, not receiving as much attention as usual, assuaged her insecurity by getting drunk and slurring non sequiturs over our conversation. Bitch was cock-blocking me. To revert attention back to her, she threw out a low blow and resorted to tears, blathering that she was unloved, that no one cared about her. When a preoccupied Face Breaker didn't react, she cried even harder, threatening to leave because she might break out in hives.

She was desperate to fuck up my game.

Out of frustration, I pounded nearly an entire bottle of the shit. I imagined myself a fucked version of Popeye downing spinach, glowing orange, able to go inhumanly apeshit. I kinda felt like that but more so just jittery and slightly nauseous when I surprised myself by attempting the unthinkable: I grabbed Face Breaker's face the way I'd seen done in so many movies. I kissed her.

She didn't pull back or knee me in the balls. It just kept happening, blotting out Jalenne's quivering sobs. I didn't care if Face Breaker could feel my hard-on brushing up against her leg. In fact, I hoped she did. I mashed my face into hers until I truly understood how she had earned that nickname.

We kissed until our teeth clanked and my stomach made gurgling sounds. This time I got into it. I closed my eyes, committing the sensation to memory, only stealing occasional glimpses at Jalenne, who, in a final desperate act of jealousy, slumped on the floor, resting her head against the inside of a urinal. She was pretending to be passed out. The liar, I knew what she was doing. I knew all about playing dead. Bitch was watching us, hating me, being creepy, feeling unloved.

Jalenne's disintegration was just the confidence booster I needed. I pushed us out of sight into a toilet stall, slid my hand down Face Breaker's pants, and gloriously finger-fucked her. Beneath the bathroom stall, I could see Jalenne's arm sporadically jump and spasm, causing an empty bottle of St. Ides to roll across the floor. As I worked Face Breaker's pants down, I noticed the inside of her thighs were dotted with cigarette burns. I wondered whether or not they were self-inflicted. I clearly had no idea what I was doing, but she let me work at it until my fingers pruned.

That night I had successfully started a process that would isolate, sever, and eventually kill a person.

I'd matured.

Two days later, winter break was over. I was back at school.

I hadn't gone swimming or washed my hand since. I became that kid: smelling his fingers in the back of the room, smiling. I let the smell of her pussy flavor every thought that entered my mind. I replayed that evening over and over. My grades dropped. My bad dreams stopped. I couldn't sleep. I wanted more.

After school I was genuinely surprised that Face Breaker and Jalenne weren't at their table. Could their friendship have already dissolved? Somewhat disheartened, I sat down, scanning the surface for any new meaningful cuts, graffiti, or symbols.

And beside my pentagram, I saw what I had been looking for all this time: a heart, etched with the jagged letters *P.K.* carved inside.

1996: FACE BREAKER AND EVERY DAY WAS OVERCAST PAUL KWIATKOWSKI

1996: FACE BREAKER AND EVERY DAY WAS OVERCAST PAUL KWIATKOWSKI

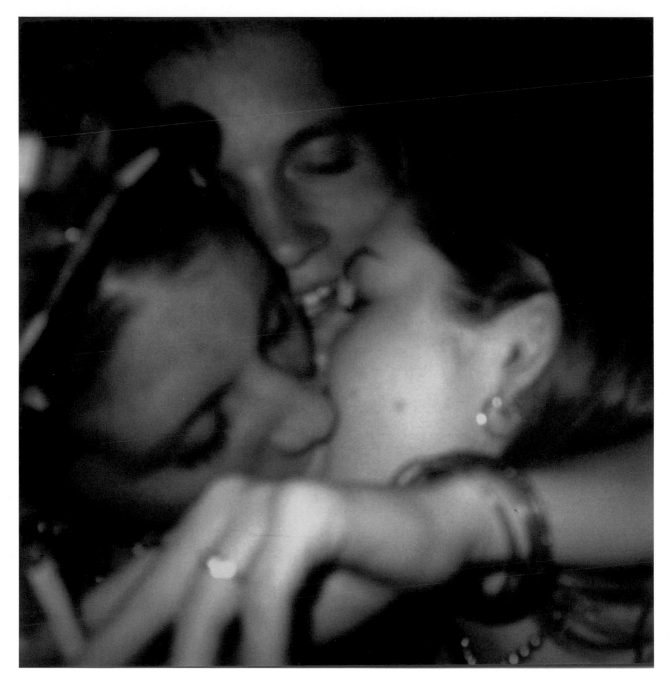

1996: FACE BREAKER AND EVERY DAY WAS OVERCAST PAUL KWIATKOWSKI

TRANSMISSION

Robert was the only kid at my interdisciplinary
high school who I knew listened to death
metal. Anyone who could recite all the words
to Cannibal Corpse's *The Bleeding* had to be my
friend.

During my fourteenth birthday party I found
him on the floor of the garage pulling blood
from his arm with a syringe, then drinking it.
I didn't know him that well, and none of us
knew how to react to that or him foaming at
the mouth. It wasn't until the paramedics came
that we found out he had tried to commit
suicide by overdosing on pills.

I was grounded, alone in my room on a Friday night. Earlier in the week, I bought myself three hits of acid. I'd been saving them in anticipation of the looming weekend of silence and solitude. Silent because my parents, as a tactical addition to my growing list of punishments, had decided to confiscate my CD player. They hated that I only listened to death metal. My mother said it gave her anxiety. My father was confused, disappointed.

That night after my parents fell asleep, I switched out the iridescent light bulbs in my room for red ones, took all three hits of acid, pulled Cobain's radio out from under the dirty clothes, and for the first time turned it on. As it hissed then crackled to life, I was immediately brought back to that day on the bus. I could even smell the burped-up cereal.

I kept the acid inside my mouth until the tabs turned into a pulp. I sucked in as much saliva as possible to swallow them down with. I knew it didn't make any difference if I digested them, but I wanted that night to be intense. It was the first time I had ever done acid alone. The effects kicked in quickly; within fifteen minutes my walls were breathing vascular flaps. The floaters gliding over my eyes looked like fat crustaceans. I became overly intrigued with the idea that beneath my floor were narrow rivers of shit flowing through sewage pipes that connected my home to other homes and back. Clearly, I was tripping balls.

All night I lay there motionless, clenching his radio to my chest, feeling the sound vibrations tunneling into my lungs. I was sifting through currents of distortion, waiting for that one signal, word, breath, cough, *anything* that would prove Cobain was still out there, alive.

Instead, I heard more rolling waves of static occasionally punctuated by pirate radio signals of Latin music, muffled trucker jargon, jerk-off talk, church organs absorbing the pious ramblings of low-budget evangelicals. This clusterfuck of noise was Cobain's safe place. This was where he went to escape us.

174

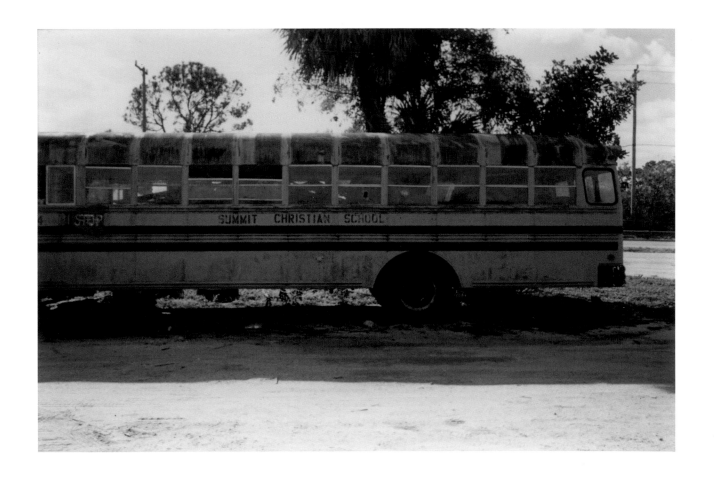

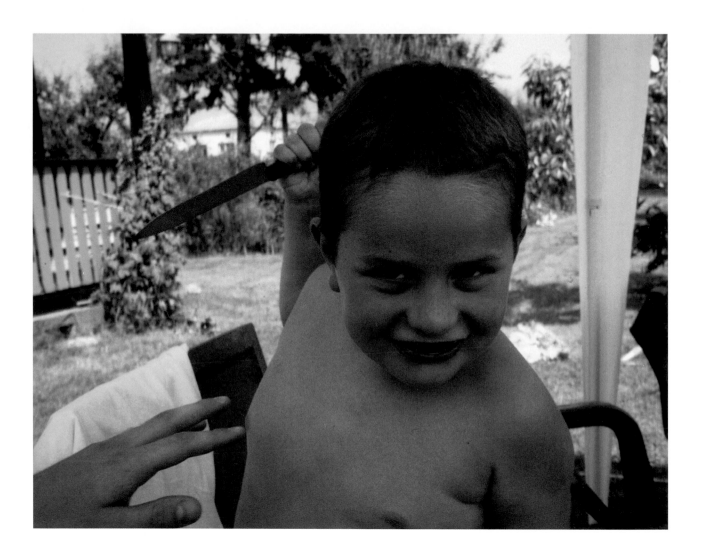

1996: ATTEMPT FAILED AND EVERY DAY WAS OVERCAST PAUL KWIATKOWSKI

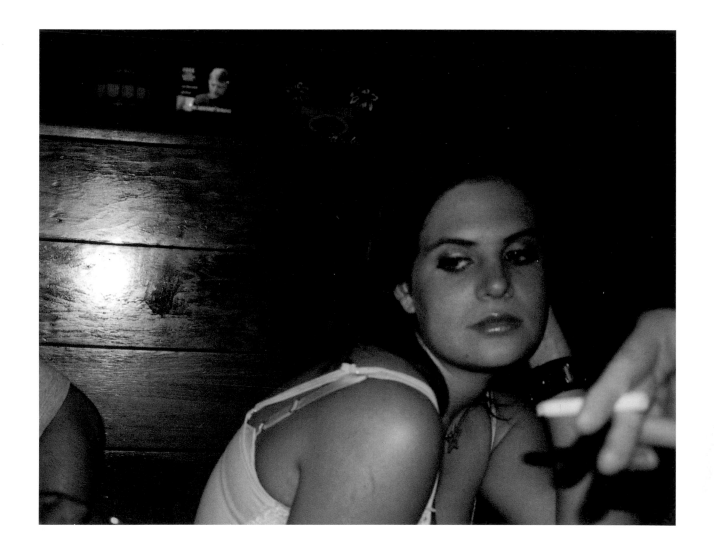

177

The chalkboard in the background reads:

Dec. , 1997
p. 255 #4-21 + WS. 5.6-
5.7
#3-40, 49-56
(+32 PROOFS)
(SKIP #31)

ave a
ery merry
hristmas!

PAUL KWIATKOWSKI AND EVERY DAY WAS OVERCAST **1996: ATTEMPT FAILED**

1996: ATTEMPT FAILED AND EVERY DAY WAS OVERCAST PAUL KWIATKOWSKI

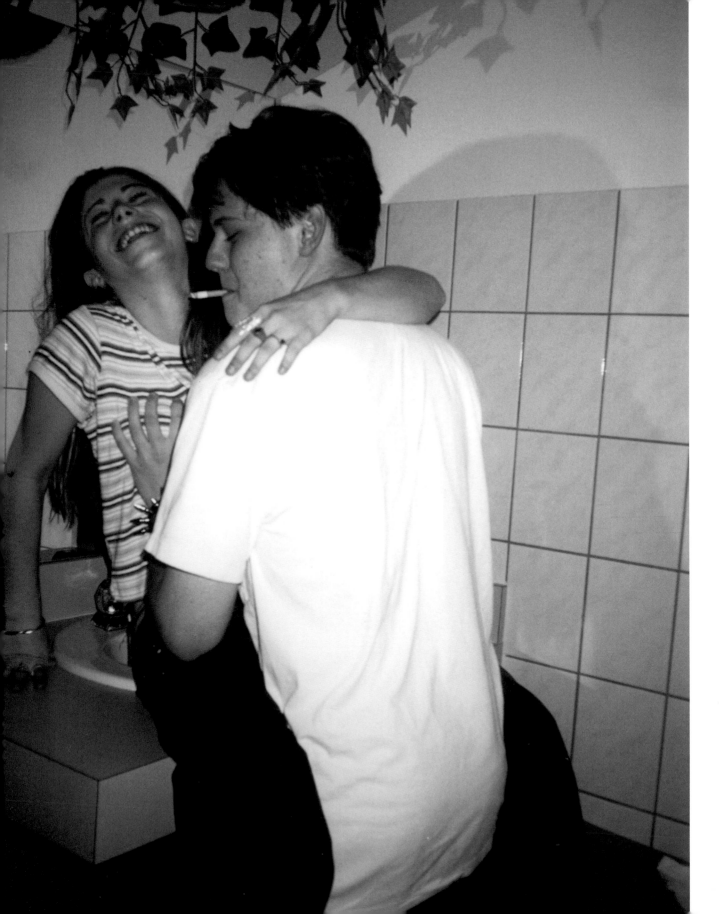

1996: ATTEMPT FAILED AND EVERY DAY WAS OVERCAST PAUL KWIATKOWSKI

183

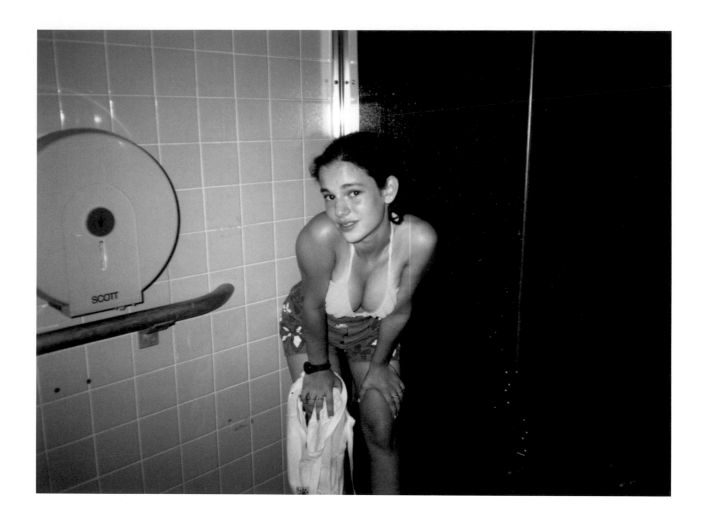

AND EVERY DAY WAS OVERCAST PAUL KWIATKOWSKI

TRANSMISSION

God bless the girl who'd use my disposable camera to take photos of girls I liked in the locker room. I almost miss those awkward days of jittering in line at the Walgreens photo developing center.

PIRANHAS

✕

Swim team was my only involvement in sports. What I liked most about swimming were the three girls on my team: Leah and Misty were sisters. They wore their hair in braids because that was the way Heather liked it.

Heather was into tough guys. She dated lots of skinheads. It was rumored that her current boyfriend Jason was born in prison. As a birthday present he bought her an authentic swastika pendant. I don't think she was into the meaning behind the necklace but she proudly wore it during swim meets.

I occasionally bonded with Misty over bands like Ministry and Pantera even though I knew she still kept boy-band posters in her room. Leah generally ignored me, which made any photo she was in even more enticing.

Because Heather's boyfriend was featured on *Cops* for a domestic-violence dispute, she became an involuntary minor celebrity. At school, no one openly teased her but her position in the social hierarchy had been tainted. After the show aired, Heather quit the swim team and moved away with Jason. I haven't seen her since.

190

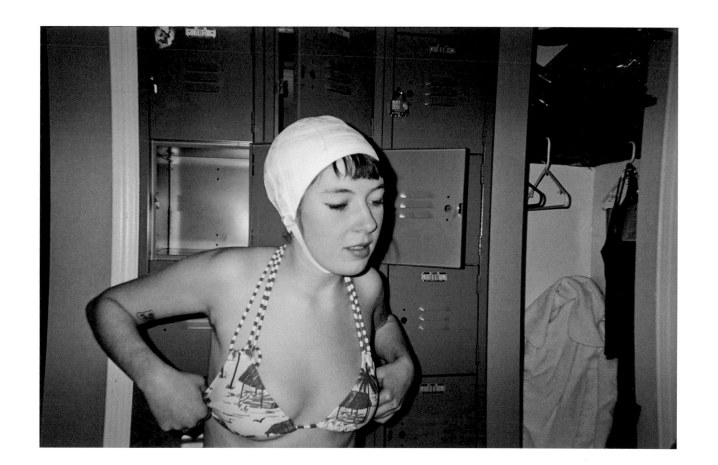

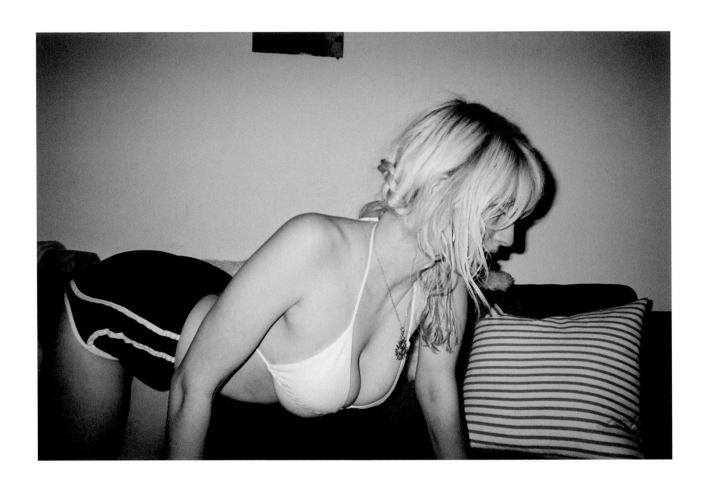

1996: PIRANHAS AND EVERY DAY WAS OVERCAST PAUL KWIATKOWSKI

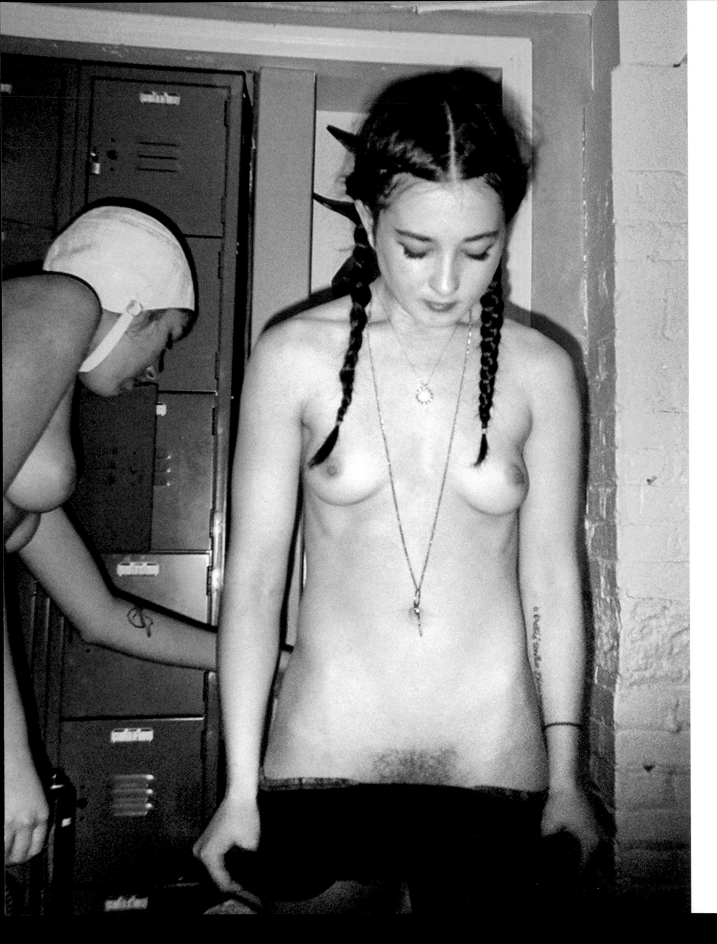

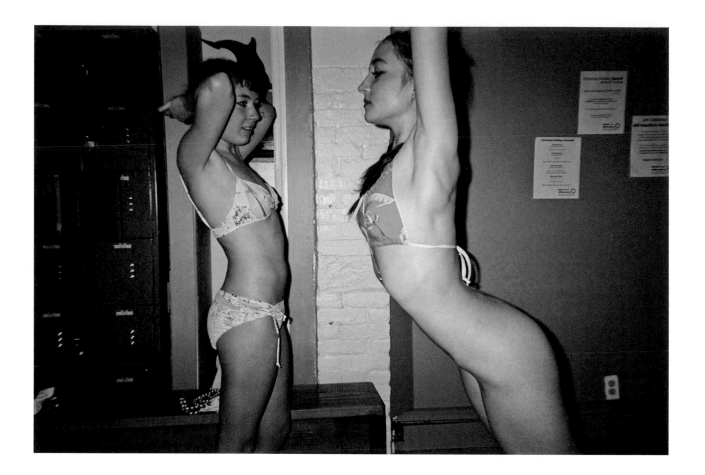

196

1996: PIRANHAS AND EVERY DAY WAS OVERCAST PAUL KWIATKOWSKI

TRANSMISSION

They used to color ketamine orange with food dye and sell it to the preps as horse tranquilizer for three times the price. I remember watching them feed lines of it to some kid at a party until he overdosed and foamed orange at the mouth.

1997
RODE HARD AND
PUT AWAY WET

✕

Eleventh grade. Saturday night.

My friends and I were hanging outside a strip mall, washing down sodden Big Macs with 7UP spiked with codeine cough syrup and vodka. We got the cough syrup from an asthmatic friend who hoarded medication. As usual we sat along the periphery of a defunct water fountain that was part of a bankrupt movie theater. That section of the strip mall was inside a mini cul-de-sac partially hidden from the parking lot. It was funny to think that after the cinema failed we still flocked to it the way baby elephants cling to their dead mothers for days after their death.

Despite having lost my virginity, and gaining newly found confidence, I hadn't gotten any more pussy. My lack of progress was attributed to getting too drunk to recall anything tactile about the experience past a cloudy mental slide show.

The memories I do have of that night are of me at a party drinking several bottles of another saccharine malt liquor called Cisco, followed by a long succession of tepid vodka shots with a semi-pretty girl whose name I didn't know. She had brown shoulder-length hair, a gangly but toned body, grapefruit-sized tits, and an upturned nose that lent itself to the fact she attended a private high school.

Then there is a short gap of nothingness followed by the aforementioned brunette and me in the bathroom, naked, chugging more lukewarm vodka, me slipping on wet tile, more drinking, sloppy kissing, clanking teeth, my cock making contact with her vagina, possibly penetration. I'd never drunk that much alcohol before. Pacing myself was a lesson I wouldn't learn for years to come.

Next I woke up in an empty guest room, alone, brutally nauseous, elated yet downtrodden: I never got her name and we hadn't exchanged phone numbers. What heightened my shame most was that I couldn't recall if I blew a load or if my dick actually made it the entire way inside. All I knew was that it was enough action in the eyes of my friends to claim that I was no longer a virgin.

This time I would have to exercise a more controlled method of numbing out so I could get past the "making conversation" stage with the two girls sitting beside us at the fountain. One was a dumpy blonde with huge tits, the other stunning. I recognized the gorgeous one as Crystal, a former classmate.

208

Back in ninth grade, Crystal dyed her hair a different color every week, wore braces, and lined her mouth with lip liner a shade darker than her shimmery bronze lipstick. She sagged her pants down past her ass crack to show her thong straps. She exclusively wore shirts featuring thugged-out versions of Looney Tunes characters.

Thankfully Crystal had outgrown that unassuming air, maturing into a girl who didn't require much effort to look hot. Now she was blonde and waifish, with a solid ass. And even with the removal of her braces her lips still swelled when she smiled. To top it off, she had a slight gap tooth, a detail that made her beauty even more devastating.

In the one class we had together, if given the option I'd sit directly behind her to absorb her. I committed details to memory like the wispy hairs that grew out below her hairline, the ever-changing patterns of her thong, the dimpled midsection of skin below her shirt, the tiny buckle of her bra strap and, most important, the contours of her burgeoning ass punching through baggy raver pants. I imagined going down on her would taste salty and semisweet, like eating peaches at the beach.

In the hallway, black kids would shout, "mean white bitch," at her. Most kids assumed she was stuck-up because she didn't put effort into being friendly. I liked that about her. They, like most boys, were only interested in loud girls with the physical attributes of piggish breeders whose beauty would surely fade immediately after high school. In my circle of friends I was never the smart one, but even I knew she was too attractive for our town.

Back at the fountain, after adequately anesthetizing, I gathered the balls to speak up. Using the dumbest (even by my standards) pickup line ever, I blurted out, "I'd rather eat you than this hamburger!" My squad of goons cupped their mouths to muffle their laughter, snapping their fingers to further drive home the jeer.

What happened next surpassed all realistic probability. Crystal and her fat friend—blank, expectant, waiting for more—sat beside me. Too faded to come up with another profound statement, I fumbled on, minus the help of my crew, blathering in a slightly hip-hop-affected diction so that she'd think I was used to negative attention. Crystal played along perfectly, filling in the gaps of silence with laughter that came out sounding like a fluty shiver.

Dumb drunk, I told her she was fine.

Nothing flickered in her eyes when in response Crystal said I was cute.

She wrote her phone number on the back of my hand with a Sharpie pen she kept in her pocket. Watching the ink bleed into my skin I thought to myself, how lucky am I to have just been owned.

I don't remember how it happened, but two weeks later Crystal and I were "dating." Our sudden boyfriend-girlfriend status was beyond my comprehension. It just happened. All my life I imagined the process of attaining a girlfriend to be more involved, like a lifetime goal. Instead, it transpired involuntarily. The experience had for the first time made me believe in the possibility of hope. I actually believed that if I obsessed long enough and caused myself enough suffering, some collective authority could pardon me.

Despite our dating status, we hadn't had sex or even kissed. Since I attended a different high school, we hadn't hung out. All interaction was over the phone. Each evening at around seven, Crystal and one of her girlfriends would call me.

Crystal would ask me what I was doing, then smother me with questions: How many girls have you kissed? Do you know how to French kiss? Are you a virgin? How many girls have you fucked? Why are you so quiet? You didn't seem so shy the first night I met you? Are you a Scorpio? What do you do if you're alone so much?

I, too nervous to elevate the conversation to anything of substance, made over-exaggerated shuffling sounds like I had things to do. There was no way I could honestly answer any of those questions without the fear of Crystal thinking less of me.

Her less sociable friends asked sarcastic questions: Have you ever butt-fucked anyone? Made out with a guy? Are you gay? Been in a threesome? Are you a loner because you like to jack off too much? On more than one occasion I'd overhear a friend whisper, "God he's so weird." They'd always giggle at my earnest responses or lack thereof. I never knew how to retort. Even though they annoyed the shit out of me, I was powerless to hang up.

After the first week of questioning, I'd listen in on Crystal talking about how awesome some DJ's set was, how lame her mom was. She'd tell me about a rave she couldn't get a ride to and how boring people in our town were. All I could do was both agree and hold back my judgment.

To choke out the awkwardness on my end, I'd turn on Retard Radio, hoping Cobain was still alive, out there, listening in on the conversation, sharing in my discomfort. Sometimes I fooled myself into thinking that he was rooting for me.

After the third week of our "relationship," I asked Crystal if she'd like to go on a date with me to the beach. Beside her I could still hear a

runt friend laughing at the ridiculous way I had phrased it.

Even to this day teenage girls have an inane ability to make me feel like a little dog that piddles itself when excited. Thankfully my humiliation was rewarded and Crystal agreed. She said that if I came to her place she'd convince her older brother to drive us to the beach.

Outside her place was a lowered Honda Accord with a silver decal across the tinted back window that read TOO LOW FOR FAT HOS. The little car belonged to her brother, Bricen, and it intimidated the fuck out of me. Bricen was a huge wigger and pot dealer. His clothes, hat, and sneakers always matched and were incredibly clean. It was rumored that he put a kid in a coma during a fight at the theater where I met Crystal. Inside, the house was immaculate, enthusiastically decorated with wicker furniture, Buddha statues, and African masks beside framed photographs of sunsets with inspirational Bible verses. Her two significantly younger siblings appeared to have developed a constant state of chicken pox that I imagined would later manifest into acne. Her home life confounded me.

Her mother didn't make an effort to turn around to say hi when we walked past the kitchen. I only caught a glimpse of her standing there looking out the window at nothing specific. From the passing glimpse I imagined she may have been hot in younger years but had since paid her dues. She was an aged, rode hard and put away wet, version of the blonde in *Who's the Boss* mixed with the creepy sick aunt from *Pet Sematary*. When she asked Crystal about where we were going, her southern accent sounded old-timey with an almost regal enunciation. She ignored me completely.

The walls of Crystal's room looked liked her psyche exploded onto them as a Rorschach test of penciled-in boy names (some crossed out), phone numbers, torn-out magazine pages of models, parts of song lyrics, and a quote I recognized from *The Breakfast Club*: "When you grow up, your heart dies." I was tripped out to be inside a room I had only imagined from the other end of a telephone line. Again I found myself hopelessly looking for clues that could give me some leverage, to find some commonality that would impress her. I'd have better luck finding significance in bathroom graffiti.

I patiently sat on her bed watching her pace dizzying circles preparing for the beach. We hardly spoke. She faced a small mirror inside of a larger one plucking her eyebrows until tiny beads of blood bubbled up along the sides, bobbing her head along to loud trance music, recalling a boring story about a rad DJ she met at a dope house party.

Like every girl I wanted to bang at school, she was preoccupied with raves and DJs. A genre I never connected with. I was still listening

211

to death metal, a genre as alienating to most people as techno was to me. I pretended not to mind. Instead I sat there waiting, retardedly watching her cram clothes, small handbags, makeup, pipes, lighters, and sunscreen into a larger bag. She layered towels across the top to hide the paraphernalia.

During the ride to the beach, Bricen hardly acknowledged me but at least hooked us up with a dime bag. He agreed to drive us back to their place before it got dark. The inside of his car reeked of every type of smoke imaginable. He didn't listen to music and cranked the AC so high the windows frosted over.

I was excited to see Crystal in a bathing suit. Even more excited to show her what my body looked like. I'd put myself through a rigorous daily routine of push-ups and sit-ups for the last month in hopes she'd take notice. When her shorts came off and her body was revealed to me, her ass had a bruise in the shape of a bottle cap. Otherwise her body was slightly more boyish than I imagined. Still I didn't care.

She packed a bowl of weed and shotgunned smoke into my mouth from hers. It was the closest we came to kissing. Before I could get excited about it, she positioned her body away from me, speaking at the ocean. She said that she smoked that way with all her friends.

Stoned, I focused on the bruise, asking if I should've said something more to her mother,

that I'm usually good with moms. I could even be charming.

She replied, "Fuck that bitch." I assumed that the bad vibes at home were a result of her parents' unexpected divorce. She claimed that her father split without explanation but still paid child support and rent, allowing her mother the freedom to clean the house until she fell asleep on the couch every night watching *M*A*S*H* reruns.

Newly single again, her mother believed that she, Bricen, and the younger siblings had been bedeviled, beyond redemption, and therefore disregarded them. She also told me that her mother used to be so uptight she refused to breastfeed, deeming it a perversion. Crystal's distressing family situation made my dick even harder for her.

Throughout the day we smoked all the pot Bricen gave us, shotgunning smoke between us. Each time I hoped the close contact would lead to a kiss that never happened.

We spent the day laid out side by side, spacing on what shapes we thought clouds looked like. She said the jagged ones near the sun looked like a Treasure Troll with an orange diamond lodged inside its belly button. I said they looked like a giant alligator's mouth about to swallow the sun. She then paused as though I'd said something wrong and blurted out, "I want to lose my virginity to you."

"Why me?"—a stupid question I should've kept to myself.

"I dunno, because I like that you're an asshole. I guess, I think that's cool."

It never occurred to me that I was an asshole or at least unilaterally perceived as one, that my silence over the phone could be taken as indifference. The latter part of her statement made more sense when I thought about it in context of the pickup line I used at the theater.

Too stoned, I over thought it. I got nervous and intensely self-conscious. I'd been telling myself all day not to let the weed make me paranoid and ruin the day. Part of me wanted to let her know that I cared. I cared a lot but knew that whatever came out of my mouth would be wrong. If I told her what I actually felt I'd ruin my shot at getting laid on the regs. Maybe I was an asshole?

She took another hit off the pipe, sealing in the smoke. For the first time she kissed me while blowing it into my mouth along with an intense creeping paranoia. The inside of my bones felt hot then cold the way I imagined falling in love to feel like. I had become fearful for us.

That evening we fucked in the backseat of the now legendary Honda Accord out in front of her house. I came in less than ten seconds. Right after my stomach knotted up, my hands and feet felt filled with tiny pieces of sifting glass. She shuddered with my cock still inside her then climbed off me, zipped up her shorts, and said that she can see why people in movies always want to smoke a cigarette after they fuck. I couldn't tell if she was being sarcastic or not. I knew that I was supposed to hold her or something but instead all I wanted was to be unconscious.

That night the sun felt sucked out of the sky. I never felt darkness so consuming. It exposed me in a way I had never experienced. I sat alone at my spot beneath the overpass. The years spent spitting for wishes off the side of a bridge had finally paid off. The sex wasn't much to speak of but at least I was no longer a sexual leper. Crystal's pussy sanctified everything. I sat on top of the universe. Whatever imaginary world crowded the celestial plains was meaningless. Angels were homeless stalkers perched atop palm trees. God, the leering pervert, heralded my accomplishment with another storm. There was no need for heaven.

Throughout all this, there was a bottom line: it was one that would resonate with me for life, drumming at my head, dissolving the weak parts, and allowing me the opportunity to attain a sense of confidence. The ability to get laid was within me. I had that talent. It came naturally to me. I would become an asshole.

213

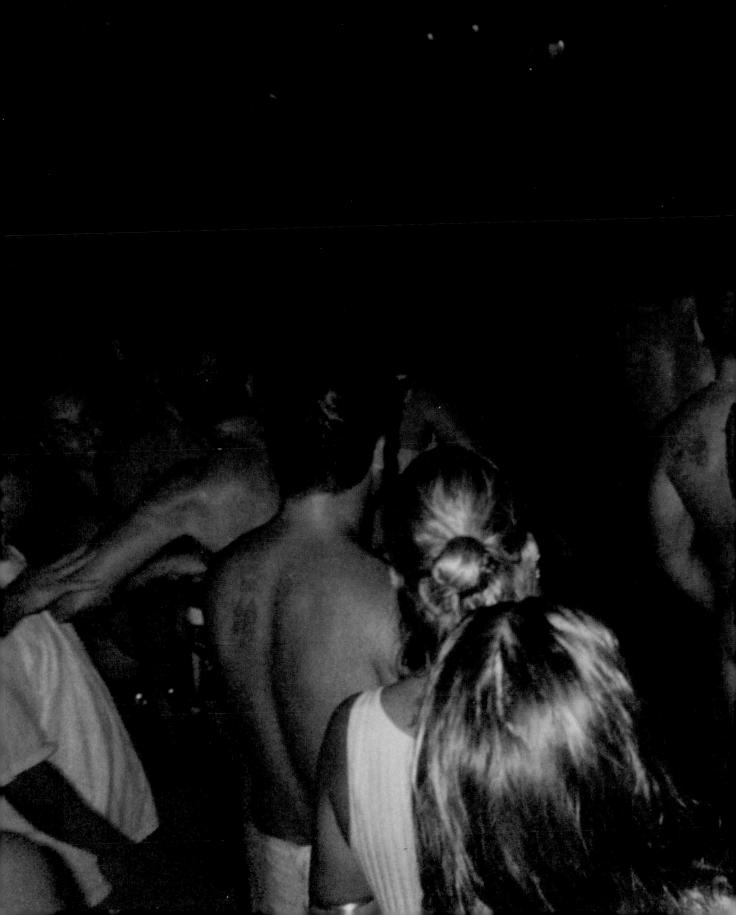

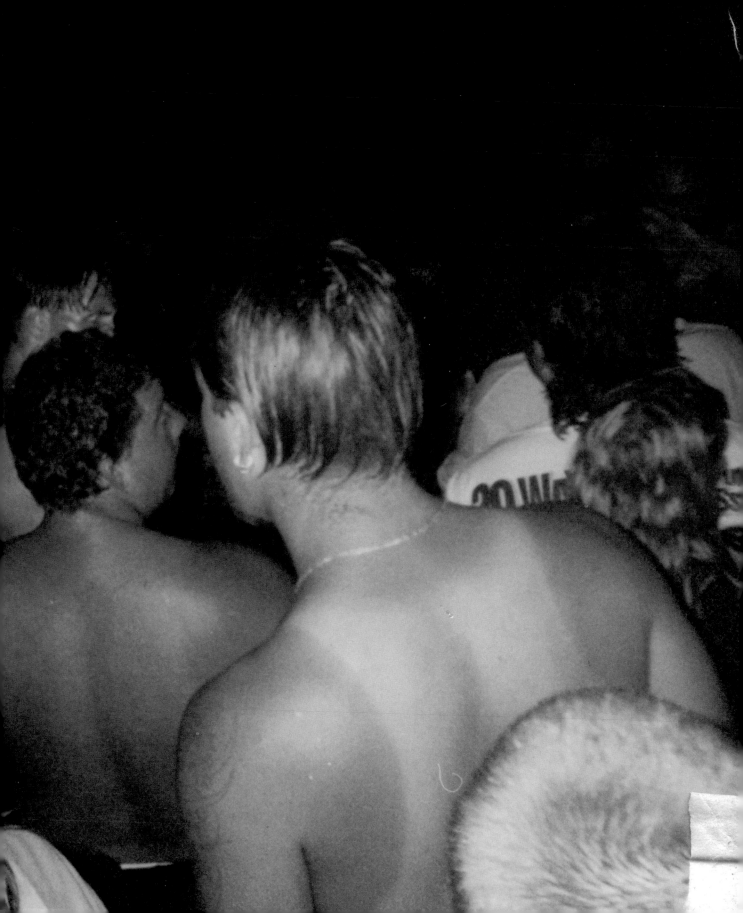

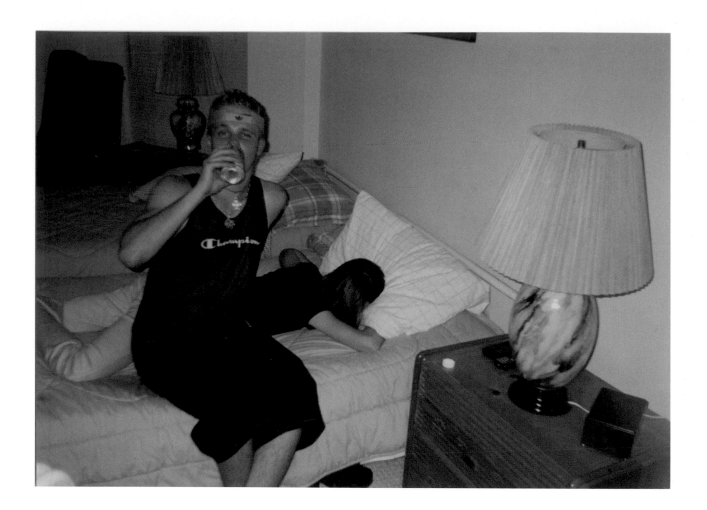

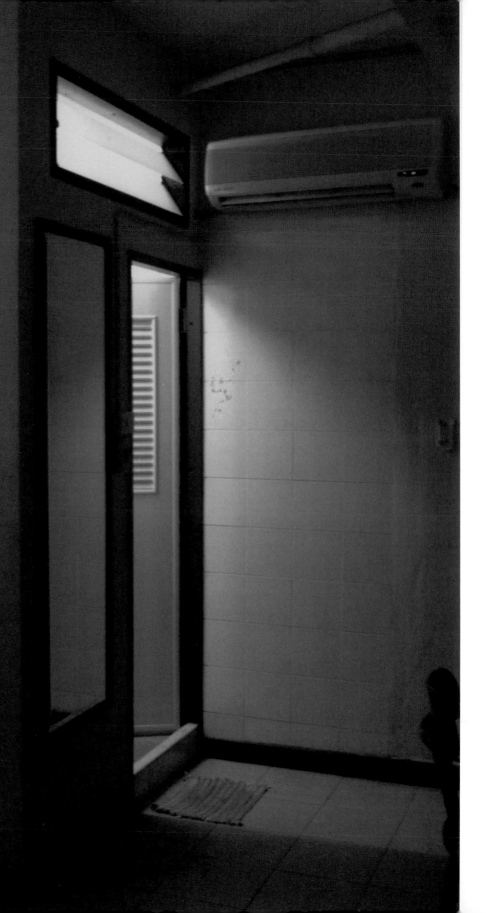

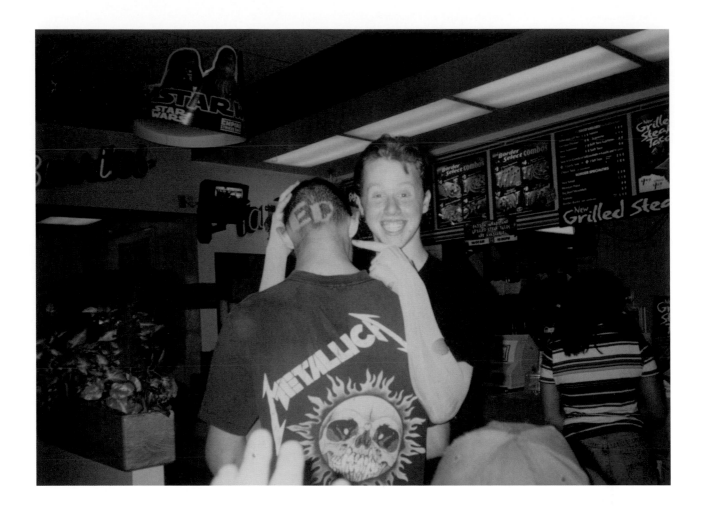

1997: RODE HARD AND PUT AWAY WET AND EVERY DAY WAS OVERCAST PAUL KWIATKOWSKI

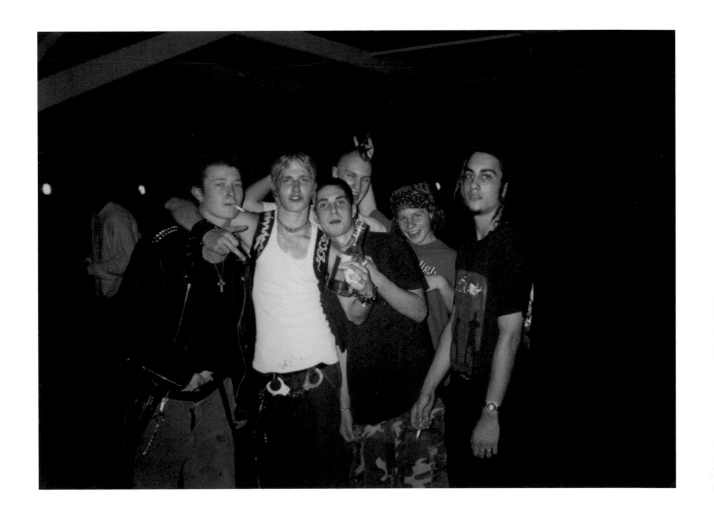

220

1997: RODE HARD AND PUT AWAY WET AND EVERY DAY WAS OVERCAST PAUL KWIATKOWSKI

223

1997: RODE HARD AND PUT AWAY WET AND EVERY DAY WAS OVERCAST PAUL KWIATKOWSKI

PAUL KWIATKOWSKI AND EVERY DAY WAS OVERCAST 1997: RODE HARD AND PUT AWAY WET

TRANSMISSION

During the mid-'90s in South Florida, a rogue
pet owner began releasing (now illegal) store-
bought piranhas into the canals. As children we
were urged to never go near the water. If the
alligators didn't kill us, the snakes would, and if
the snakes couldn't, surely the piranhas could.
To thin out their numbers, the Florida Fish and
Wildlife Conservation Commission poisoned
the water. The next day, hundreds of various
fish were washed up on the shore.

FINAL TRANSMISSION

✕

Kyle was the first of my friends to own a computer and have internet access and the ability to navigate through it. At the time none of us imagined it could extend beyond a method of trading and retrieving intensely weird porn revolving around torture, death, shit, piss, vomit, and interspecies sexuality. Within days of discovering how to image search, our brains were fucked. To us the internet became a multi-tiered digital replica of the most warped regions of our psyches.

As a result of this newfound glory, Kyle began printing out the most disturbing of these images to decorate our acid mixtape covers. Inside the plastic cases and stuffed between the layers of paper would be tabs of blotter tucked into mini cellophane bags.

Tripping started as a way to escape being at school while still attending, then slowly wormed its way into a solid habit. I didn't think much of shadows smearing into walls. Nothing freaked me out, yet nothing felt vivid enough while sober. I eased into playacting my own character. I stopped caring about being perceived as a wallflower because I didn't want to draw attention to myself. Even getting laid seemed slightly less important. I liked how rudimentary and specific life felt. I didn't have to pretend to understand all the fragments of memories, experiences, and expectations that were supposed to add up to something bigger. The past stopped mattering so much.

To my surprise, the routine also helped build a better relationship with my parents. For the first time, I found novel pleasure in articulating my day-to-day school life beyond terms like "School was good" and "I'm doing fine."

This unexpected reconciliation became an excuse for spending numerous evenings at home sitting alone up on the roof. From my vantage, I watched a gathering hurricane smolder over the Atlantic. There would be at least a few hours of calm before the storm reached inland. That was plenty of time to secure storm shutters. On the news, we'd seen footage of roofs being ripped off their foundations. I always imagined what it would be like to have that happen, to be splayed out violently, consumed and annihilated by an aberration in nature.

During previous hurricanes, Kyle and I drank mushroom iced tea from Big Gulp cups. As the hurricane neared, we'd lie side by side on the driveway screaming giddy obscenities while imagining what it would be like to be eviscerated by lightning or bludgeoned by rain. Empty garbage cans tumbled down the street, and sheets of rain snapped against our faces. Hurricane season was my favorite time of year.

This evening the energy felt different; it even sounded different, atonal. I felt suspended at that moment when you're half asleep and the ground is rushing up as you fall—then you spasm awake. I felt wind sweep over the sunburned parts of my arms, and I saw lightning

but heard nothing other than the whir of a vacuum cleaner inside someone's house. All around car doors slammed, dogs barked, babies cried, then all at once stopped.

From behind a palm, a rogue smudge pushed through the blades. Initially, I confused it as a tiny blister-hued cloud, an offshoot of the storm. The loose footing I had in this world paled. Barf ran down my shirt, but I don't remember being sick.

I escaped to the relative safety of my room. Downpour blasted against my bedroom walls, jangling the storm shutters in their frames. Sitting up in bed, no music, no lights, I was positive Cobain was orchestrating a new message. There was a disturbance in pressure like another dimension of sound had sieved through. I thought about pressing the receptor button to let him know I was listening. But what if I scared him off? Interrupting was a bad idea.

I figured out a way to run Cobain's radio through my guitar amp. If I positioned the speaker on my nightstand and aimed it at my head, the gravelly chatter canceled out. That night it gave way to the sound of two skittish birds fluttering inside a thin wire cage. It was coming from his end. They had to be coming not far from where he was standing. I shut my eyes tight until the interference fizzled out into a minty coldness starting at the base of my scalp, wrapping around my eyes and forcing them to bug out. The tiny vibrations made me sneeze. Each time I did so, parts of my body fractured into a tangle of veins, spit, skin, teeth, and nerve endings.

Finally the signal cleared, void of disturbance. I could hear his pulse as steady blips in the static; somewhere a car glided down a wet dirt road, starched clothes rustled, a barely audible yawn registered—definitely Cobain's yawn. To imagine where he was, I pictured the landscape as a map of whorls, tiny transparent vortexes. I believed that inside each of those cyclones of noise was Cobain.

The next day, my spit tasted metallic. The morning wood I woke up with was un-jack-offable, persisting throughout the day. Beneath the surface, my skin tingled like some essence of myself had slipped out. Around this same time, it was being pointed out to me that I wasn't acting like myself. My nostrils filled with rust. I blamed the frequency of my nosebleeds on stress. There was a steady rise in anxiety I couldn't place. During conversations, I often fumbled over my thoughts trying to assemble coherent sentences. The sound of words separated before reaching me, like whatever air the conversation clung to suddenly fell flat. My parents urged me to go on a regimen of mood stabilizers that made me less wide-eyed. Part of me knew that if I stopped taking so much acid, things might readjust, but the better part of me knew there was a bigger problem.

Each night I drifted slightly further from myself.

231

Dear Paul,

I don't like things the way they are now. I don't know why they are like this because nothing bad happened. I feel like sometimes you just cut yourself off from me and you won't tell me anything. It feels like you are having a hard time right now with how you feel about things I don't know exactly what is wrong, but I feel like it isn't really about me because I've tried everything and I've run out of things to tell you or try to make you feel better.

You're letter was everything I want, but you don't act like that's how you feel so I keep feeling like maybe you've changed your mind or something.

I meant what I said I felt for you and I hope that isn't part of why you suddenly stop talking to me. I try not to act like you don't talk or whatever, but it's just gotten so akward with us and it makes me wonder if you talk to anyone? I feel like we have come so far and yet we can't go on unless we can open up to eachother more. I also feel like I have tried very hard to do this, but it's like I'm talking to no one. I want to know you in every way that people can know eachother and I want you to know me. I love you Paul, and I can't dismiss what I feel we have. Why can't you talk with me? I feel numb and at times I want to cry but I can't. I want you, and I want us to be O.K.

I want to know if you still feel the same because you don't show anything.

The part that meant the most to me in your

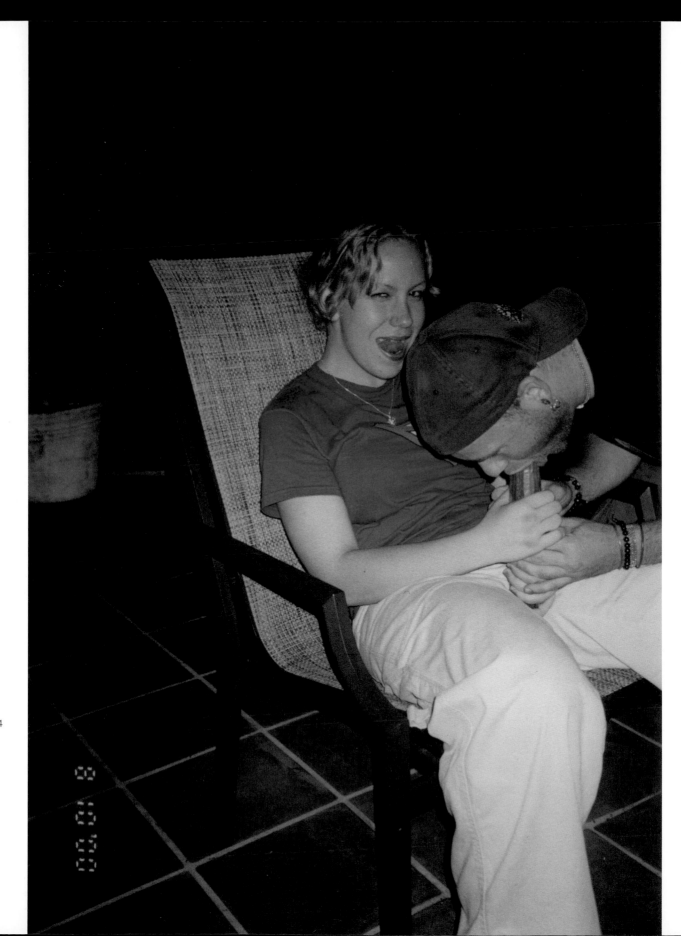

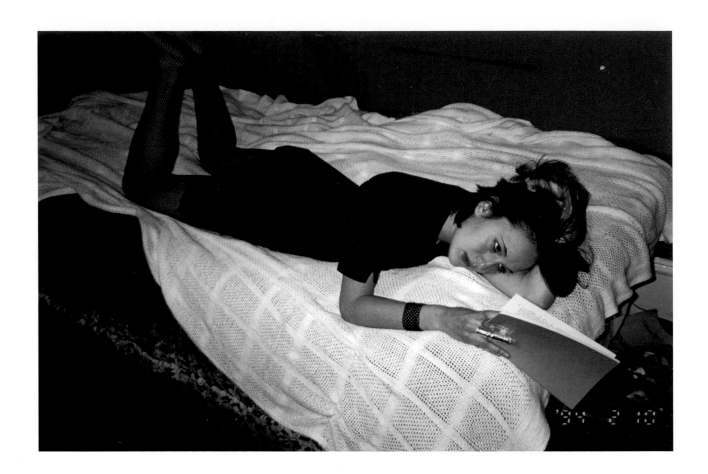

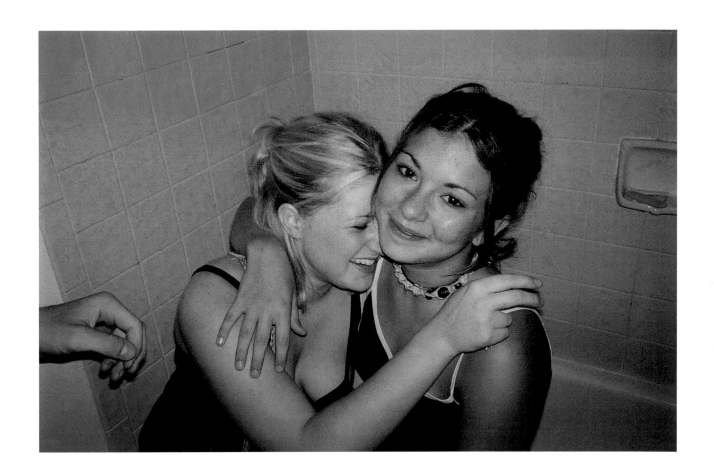

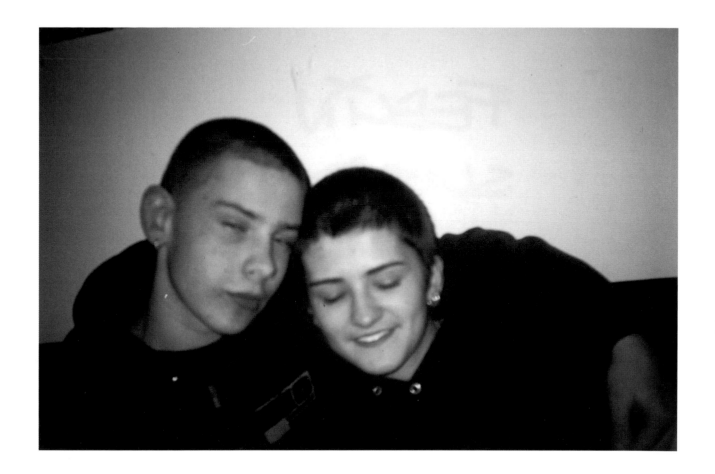

PAUL KWIATKOWSKI AND EVERY DAY WAS OVERCAST 1997: **FINAL TRANSMISSION**

1998
KID TESTED,
MOTHER APPROVED
PART II
✕

I was seventeen and finally able to drive. I considered this to be a radical demarcation between watching the scenery and actively participating in life. I loved the freedom to disappear.

It was a Friday night and I had been guilt-tripped into chartering my sometimes-skinhead friend Lee to meet two girls he'd met at a ska show I had refused to attend. Their names were Shianne and Rainey. We went to Rainey's house on Hialeah, which smelled like cedar chips and urinal cakes because of her pet ferret.

Shianne's skin looked somewhere between pockmarked and sandblasted. She was both pale and ruddy. Her hair was partially shaved into a Chelsea cut, and she had on baggy Jncos—two of the most unflattering looks on a girl. Rainey was a fat Goth. Beneath layers of candy bracelets, her wrists were corrugated with scars. They were both cutters. There was something parasitic about their interactions with each other. It was as if they were one and the same, a two-headed pig that head-butted itself to feel alive. I could hardly look at them. Lee wanted to fuck the fat one.

To pass time, we took turns doing shots of vodka from a plastic jug. As the girls got hammered, they became oblivious to us, more interested in chatting with other Goth girls via webcam. On the computer screen, all their rooms looked the same: dingy and cluttered.

I envisioned them trapped in tiny virtual pods, orbiting the planet but never touching one another or touching down.

It wasn't long before Shianne, Rainey, and the webcam girls were daring one another to make out. My only contribution to this game was convincing Rainey—the fat one—to let Lee shove a bottle in her ass. After a word or two, she actually bent over but Lee pussied out. Like most skinheads, he could only do something if five other guys were doing it too.

I had given up on thinking I could drink myself into wanting to fuck either of them. The situation was pointless. I was bored, drunk, and alone, trapped between a two-headed pig and a hopeful swine-fucker. I claimed I needed to piss and explored the house.

Rainey's mom was sitting in the living room alone, watching Conan. I couldn't tell if she had noticed me, so I said hello. She looked up startled.

It was Hailey.

She timidly introduced herself and asked how I knew her daughter. I told her I didn't. She had no idea who I was. Since last I saw her, Hailey's naturally pouty lips had become swollen and gloss-sloppy. Her perky hair had collapsed into matted strands.

242

She couldn't hold eye contact without blushing. It never occurred to me that an older woman could be interested in a seventeen-year-old boy. She asked if I was bored with the girls and wanted to watch Conan with her.

Before I could agree my moment was interrupted by Rainey. She mockingly screamed from the kitchen, "Oh my god Mom, are you flirting with that guy?" Shianne chimed in, "Do it, dude! She needs a good fuck."

Hailey turned bright red as she sent the girls back to their room. Down the hall I saw Lee cutting lines of Oxy on the sly. I was relieved knowing they'd all soon be passed out.

We were alone.

Hailey's eyes were unfocused. I could tell she was drunk. Though she was looking at me, her eyelids flickered like she was trying to focus on something far behind me.

Sitting on the other side of the couch, I made a half-assed attempt at small talk. She stayed friendly enough but unresponsive. There was a lot of staring followed by a long pause during which I panicked thinking of the right thing to say. She giggled. I could tell she enjoyed watching me squirm.

In an almost commanding but tender voice, she asked me to help her move two boxes from her room into the attic. I noticed the boxes weren't sealed. They were filled with boring shit like documents, books, albums, and opened envelopes. Upstairs in the attic I glanced inside a few of the envelopes. They were mainly family photos as well as personal outtakes of Hailey in the mix. I was never much of a thief, but stealing those pictures was one of the best crimes I ever committed.

Everything after felt like a dream. When she kissed me my stomach raised up and felt hollow. She pulled down my collar, leading my head between her legs. Having pussy come to me this effortlessly was unreal. With her panties still on, I pulled her thong to the side, then ate her out. Along with Hailey's guidance she was the first woman I ever made cum, and in return she let me finish in her mouth.

243

In less than three years I watched Hialeah Drive, a street of maybe eight middle-class homes, go from dilapidated to annihilated; all the families moved out after nearly every house was burned down inexplicably. The police never found any witnesses. When asked, they would say there were too many suspects to even consider an investigation. The few homes that weren't set on fire eventually collapsed from neglect. Over time their remains receded into the swamp, and Hialeah Drive became a dead end.

I still think about Hailey, about her blowing me, and wonder what her mouth looks like now and whether she'd still remind me of Peg Bundy.

I wonder if she still dresses like a clinic receptionist or if she's become homely. Part of me is even curious if Rainey and Shianne are still alive.

I don't know how my experience tied in with the demise of Hialeah Drive. I like to think that my encounter with Hailey caused a small ripple that eventually forced the homes on Hialeah Drive to gradually implode. Maybe some things are just meant to die slowly while we watch. I don't know.

244

1998: KID TESTED, MOTHER APPROVED, PART II AND EVERY DAY WAS OVERCAST PAUL KWIATKOWSKI

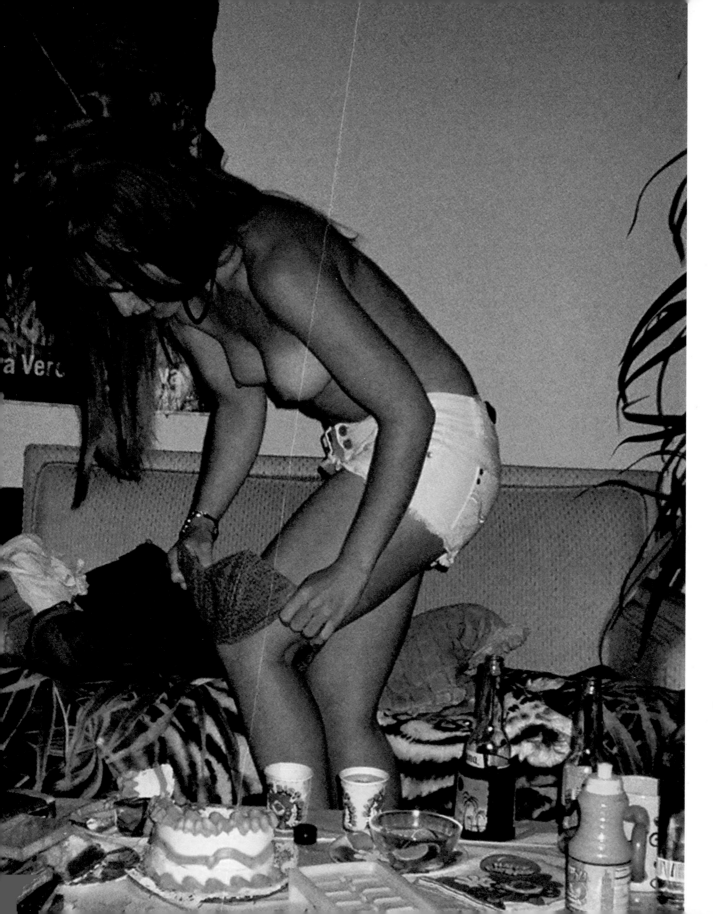

253

1998: KID TESTED, MOTHER APPROVED, PART II AND EVERY DAY WAS OVERCAST PAUL KWIATKOWSKI

255

COMMUNITY
SERVICE

✕

It was my second to last semester of eleventh grade, and the skies were an endless toilet-hued white. I had just undergone my final transition from amorphous punk/freak to hardcore kid/d-bag, finally fixing up and putting in a decent effort to get laid.

Due to several minor offenses ranging from an arrest for trespassing on a private beach, underage intoxication, to possession of a concealed weapon (brass knuckles I never used), I had to serve more than 40 hours of community service to avoid probation. I could choose the charity I wanted to work for, so I picked the Comprehensive AIDS Program (CAP). At the time I was still processing the people in my life I'd lost to complications from HIV. Seven years later, the topic was a constant strain I couldn't shrug off. For CAP, I figured at most I'd be handing out condoms outside of bars, which wasn't a complete waste of energy.

Instead I ended up working at a secondhand furniture store. I had to drive a moving van to rich geriatric women's mansions in Palm Beach, pick up furniture they wanted to donate as tax write-offs, and either deliver them back to the store or set them up in a disenfranchised family's home.

258

This is where I met Cody, my supervisor. He was an old ex-drag queen from New York City who had performed at a bunch of dance clubs in the '80s and was estranged from a politician father. He had an outlandish sense of humor and reminded me of a saucier version of Rodney Dangerfield. He had buried seventeen of his friends because of HIV and had himself been diagnosed. At the time it was healing for me to be around someone like him.

Cody's work routine started by smoking a joint during breakfast. He claimed that the marijuana dulled his nausea and increased his waning appetite. While driving to furniture collections, he'd tell me stories about the gritty 1980s Times Square peep-show culture. He made it a habit to introduce me to hustlers he knew who worked in the parks where migrants played soccer.

He showed me that, around lunch time, the drive-in movie theater parking lot would be peppered with guys in pickup trucks and Lexuses cruising, rearranging the parking scheme until pairs formed and they could peel out together. We justified these excursions to our overseers by saying we were handing out condoms at "high-risk areas."

Cody especially loved using these opportunities to show me that tons of straight guys acted like total faggots whenever they got the chance. Around lunch time, teams of regular-looking dudes on break would go to a hidden room inside a mobile-home-sized adult novelty store and circle jerk around a lone television set.

I remember he once dared me to peep into a gas-station bathroom known for being a cruising spot. The walls inside were pockmarked with glory holes. A wafting mix of urinal cake, locker-room musk, cheap beer, and cologne seemed to add to the nervous excitement of shifty townies looking to cheat on their wives and butt-fuck in the abandoned trailers out by the canals. Cody always got a kick out of how freaked out I was.

One afternoon after moving a huge wall unit from some day-drinking cougar's mansion, we lit up a joint to accompany our Cuban sandwiches. Stoned to a point where the humid fumes above the highway radiated, Cody drove to a small strip mall off the main boulevard. To the far side of the plaza was an innocuous-looking photo studio with heavily tinted windows. Around the corner, alongside a barbed-wire fence, hidden from the road, was a sign that said ALL GIRL STAFF with arrows pointing to a pink back door.

Inside we were greeted by a leathery woman with cosmetic tattoos that gleamed in the heat. She had on Wranglers, a pink bra, and a bathrobe with a badly embroidered dragon on the back. Her hair was done up in a bouffant, and when she caught me staring, she pointed up and said, "The higher the hair, the closer to God."

I was speechless.

She and Cody already knew each other. She asked him if I was interested in renting a studio with one of their models. The rooms were all pink and pastel shades of yellow—simultaneously gaudy, yet austere. I never fucked any of the "models" but asked if I could take pictures. Most of the girls were polite but had the same sedated quality of animals in a petting zoo.

I never questioned how or why Cody knew these people and locations. I enjoyed not knowing. I saw it as being given a guided tour of a town that always felt like a mindless board game, a game I glided over but never actually played. Now, suddenly, I saw past the boring topography that had been etched into my mind since childhood.

After I fulfilled my community service requirements, I never saw Cody again but took comfort in having learned that, despite having HIV, life went on for some people.

I spent a majority of that month driving aimlessly, smoking out, imagining that behind every boarded-up window in town was something grotesque and improbable. I saw people, homes, and culture in decay, but beneath the pastel husk was a pulsing mess of guts. At every intersection there were scraggly rednecks in Confederate baseball caps and SUV-driving yuppies cruising for furtive encounters. Shadows became suspect, homely women staggering beside the highway hustled, and everyone seemed to have someplace secret to be.

AND EVERY DAY WAS OVERCAST PAUL KWIATKOWSKI

266

1998: COMMUNITY SERVICE AND EVERY DAY WAS OVERCAST PAUL KWIATKOWSKI

TRANSMISSION

Like most strippers I know, the more blow she did, the more adoringly she spoke of her son. One time she fucked my friend while I nodded off in the bathroom sitting on the toilet, resting my head on the toilet-paper dispenser. As the sun came up she asked if she could borrow his Danzig shirt and a pair of sweats to look more presentable for a custody hearing.

4/20/99
SQUELCH CAPTURE

✕

At the tail end of a yearlong acid freak-out, the inevitable mental rift impaired my ability to sleep. At the onset I felt my body being lifted by unseen hands then jarred awake by an involuntary burst of synapses. I couldn't stay asleep for more than a few hours at a time. There was also occasional sleepwalking. Usually I never went anywhere cool. Most of the time I woke up in the driveway. A few times I woke up beneath the dinner table. More disturbing than the sleepwalking was that I had been told by my parents and close friends that I often laughed in my sleep. It didn't feel right that my unconscious self was capable of having more fun than the tired one.

I got used to not sleeping. Not even Retard Radio silenced the micro-pitched vibrations of insomnia. The mental cloudiness absorbed my anxiety about being a bystander in Cobain's endnote. I told myself to give up on the possibility that he'd resurface. For the last time I replayed the meaty thud of knuckles against flesh padded over bone. In staggering slow motion I watched Cobain's mouth slowly curl up into a gaping O shape. After today his world would no longer be enmeshed in my own. I packed his radio into my school bag. The heat of it warmed through the fabric against my back.

It was senior year. Finally high school quivered into its last throes. That day was also Kyle's birthday. As a present his mother allowed him to drive her Mazda to school. He was chauffeuring me to school as payback for the countless rides I provided. My present was wrapped in newspaper obituaries. It was a new mixtape. Inside the plastic case were two saved gel tabs.

Like usual, our mornings were spent hanging out a few blocks away from school at the 7-Eleven parking lot. That part of the day was used to hotbox the car and catch up on week-end exploits. Most of the time we hardly spoke to each other. We just sat there, ensnared in stale pot smoke, listening to Morbid Angel's *Covenant* album. Mentally we psyched ourselves up for the onslaught of teachers and unsavory classmates we called Human Wreckage. Luckily we wouldn't have to deal with them for long. After lunch, during the mandatory football pep rally, we'd drop our tabs, then skip out on school for the beach.

It occurred to me that I had never taken Cobain's radio outside of my room. My blissful daydream of being sprawled out at the beach was smothered by irrational panic. I believed that having his radio in public would be illegal, maybe lethal. I thought of it as a doomsday weapon that could implode, vanish, then shoot out an invisible seismic blast of despair. Life would slowly be siphoned out from this world. It was a scenario where existence gradually

274

paled then surrendered. Having made it to my senior year, and not Cobain, felt like cheating. I'd done wrong and knew it. Security guards were positioned at both exits of the gymnasium. Students were crammed in, packed atop two giant expandable bleachers. The structure was that of a stretched-out skeletal accordion that folded into the wall. Along both sides of the bleachers were doors that led to an entrance that would take us to the basement. From there we'd run through the faculty parking lot, across the street, back to the Mazda.

To Kyle and me pep rallies were a particularly alienating form of torture. What tripped me out most about them was that for some kids, "losing their shit" was triggered by "school spirit." When it came down to school activities, I'd do anything to avoid them, physically or mentally. I'd pop pills. Go stoned, on acid, drunk, whatever. It never bothered me that I was devoid of school spirit.

At the pep rally's most feverish, football players beat their chests to an avalanche of stomping feet and high-pitched cheers. That was our distraction, the signal for us to book it from both ends of the bleachers toward the side doors. If caught, our plan was to play dumb, say that we had to use the bathroom and mixed up doors. There were advantages to being unmemorable; it was easy to get out of trouble.

Inside the bleachers we stumbled over each other, allowing our eyes to diffuse darkness. We searched for the basement door by sweeping our palms in large semicircles over the wall's surface. Through streaks of light beaming in from between the slats, Kyle's eyelashes trapped puke-stain shades of yellow, orange, and brown. I never realized how long his eyelashes were.

I muscled my shoulder into a handle-shaped disturbance in the wall. There was a muffled click followed by strains of wet air. The door was unlocked. Inside, the basement was flooded. It smelled of mildew powering through bleach. At parts the cold water was deep enough to spill into my high tops.

Our creep became a casual slosh until Kyle's footsteps stopped. In the corner next to a small plaster-encrusted door was a giant sputtering AC unit. He recited a line I recognized from *Predator*: "The jungle took him. It just came alive and took him." Using a giant marker he tagged VAL VERDE on the air conditioner.

I watched him open a small valve coming from the side and put his mouth up to it like he was drinking from a water fountain. I had never seen anyone do Freon. I knew that it was a refrigerant and that only piss-poor kids huffed it—occasionally some died. Whenever that happened, at school during first hour we'd be forced to watch a sad two-minute slide show about the dead kid. Hardly anyone felt sorry.

275

Kyle sucked in the stream of hissing air until his expression went slack. His lips trembled as his complexion marbled toward pale blue. He flipped his shirt over his face. There was silence followed by the Sharpie pen splashing into water. I asked Kyle if he was okay. I told him he was scaring me. Minutes dragged before the dark breath stain on his shirt widened.

Kyle broke out of his stupor. He sopped up Freon spray with his shirt and held it out to me. Against better judgment I reached out for the rag. I held it over my mouth until my vision unfocused. The depth of whatever direction I faced rushed up in front of my nose. Ornate clusters of tiny red explosions lit up the basement. I saw my breath as a placenta-hued vapor even though I wasn't aware of myself breathing. My thoughts were random and confused. I giggled for no reason, humming a Muzak version of Ace of Base's "All That She Wants" I heard playing at the supermarket. I was exhausted, overly aware of the self-regulating cruise control that synchronized my body. The jagged lines of Kyle's VAL VERDE tag pulsed fluorescent orange, pushing out from the wall like mushy veins.

Kyle was too fucked up to drive. Like always I ended up driving. The road spilled out before us as a silvery stream, pushing the Mazda forward like we were caught in the pull of a receding wave. I liked navigating through traffic on acid; it felt simple and inconsequential like a video game.

We passed through a flickering corridor of slouching palm trees. Through the clutter in my backpack I heard Retard Radio's mechanical gurgle. I placed it on the dashboard. Seeing it there as an effigy to Retard Radio reminded me of the bobblehead characters or plastic Jesus figurines I'd seen on dashboards. Between blips of white noise it played a fragmented news report about high school kids being mowed down with semiautomatic guns. There was no known motive. The killers were also students.

At the beach, Kyle and I were laid out, burying our feet in the sand, taking note of the sky's now apparent curvature, obscuring infinite blackness. The entire day passed languid as though I was asleep. Behind us were backlit palm trees, their silhouettes matte black and jagged against the hyper-colored setting sun. Day drifted into the calm of dusk. No more white-hot light reflecting off the sand. No more searing bruise-hued sunspots in my eyes.

Growing up in Florida was like developing in an afterlife, a different kind of paradise. A place where clouds lingered, passing slowly like giant Mickey Mouse gloves sweeping over my eyelids, hands masquerading as shade, casting a spell. Everything about it felt alive, slow, brutal, seething, and batshit crazy. I thought of how much effort it took to recall a single memory of picked-clean blue skies, and despite the years of constant sunshine, whenever I thought back to a specific memory, it seemed as though every day was overcast.

I dragged the dial through a scramble of radio frequencies for another update about the school shooting. In parts, the news tallied the total number of victims and concluded that the assailants had committed suicide. Despite having no visuals of the event, in my mind, images of the prey and attackers were already filtered through the dirty borrowed lens of television.

I twisted the dial one last time. No signal. All sound got smaller. I was plummeting, not sure what direction, just away. On impulse I threw Retard Radio into the water where neither age nor time could erode Cobain's voice. I imagined every fish in the ocean suddenly floating belly up. The tide was a backwash of red sea foam, smelly half-decomposed dead things, shards of bone, and brittle seaweed.

I sifted through a mental catalog of short-term friends that vanished from my life. They smashed and fused into a kaleidoscopic gradient of faces, stretching out then separating. I couldn't remember what happened to end most of those friendships. From under water the radio's broadcast dimmed to the sound of a window shuttering in place, fading out to the staccato of chattering teeth. This new frequency would be Cobain's station.

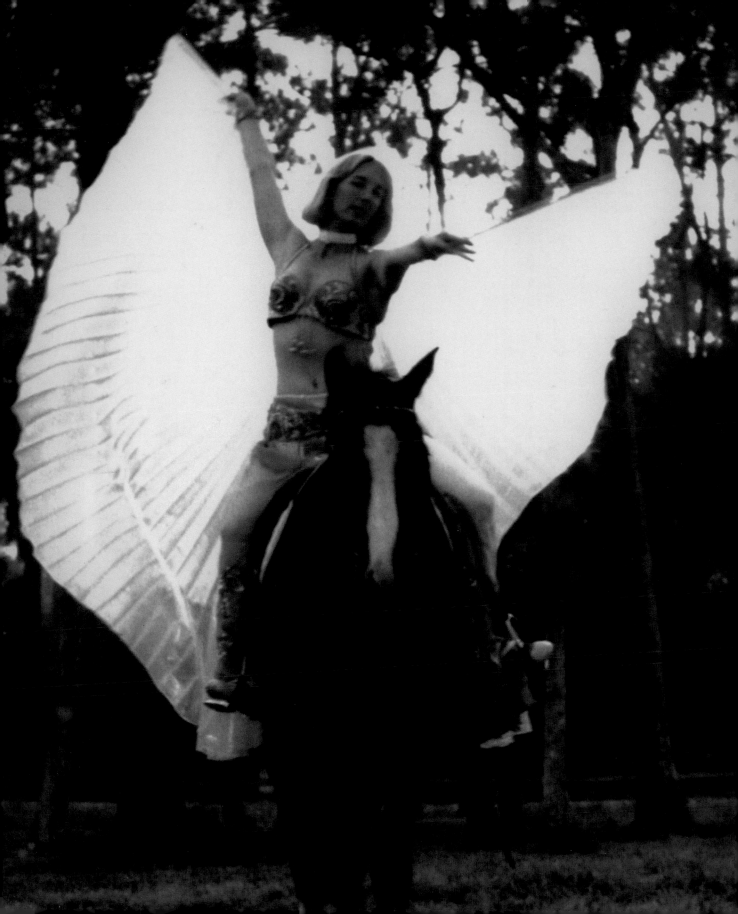

TRANSMISSION

Her real name was Janet Jackson. She was obsessed with riding horses, whiskey sours, parrots, and *I Dream of Jeannie* memorabilia. She earned a comfortable living selling hand-raised parrots from her home. Her living room and patio were fashioned into a giant incubator. Every inch of the floor and upholstery was caked in hardened layers of newspaper and bird shit. For my ninth birthday, my parents bought me a lovebird from her. It was like having a well-trained dog. The bird would sit on my shoulder and eat food from my hand. I could even take it outside and it wouldn't fly away.

After a hurricane killed off all the birds in her patio, Janet picked up a pill habit and skipped town. No one knew she was gone until the smell of decomposing birds filled the street.

Lovebirds are known to mourn the loss of a mate. Those were the first to die.

ACKNOWLEDGMENTS

Special thanks to Arvind Dilawar, Robert Siek, and Lex Weibel for their editorial contributions and feedback during the initial incarnations of *And Every Day Was Overcast*.

And in no specific order, immense gratitude to: Damien Lafargue, Myriam Barchehat, Matthew Stokoe, John Reposa, Gary Markowitz, Alec Soth, Ira Glass, Anaheed Alani, Farley Chase, Scot Sothern, Hayley Downs, Edward Zipco/ Superchief, Doug Rickard, Karley Sciortino, Jason Faulkner, Ben Carlton Turner, Bryan Formhals, Gillian McCain, Shane Lyons, Hugh Lippe, Lillie Jayne, Lauren Conrades, DSOA, T's Lounge, Christopher D Salyers, the Black Balloon crew, and all my South Florida friends and family.